How to Draw
Portraits in Colored Pencil
from Photographs

How to Draw
Portraits in Colored Pencil
from Photographs

LEE HAMMOND

NORTH LIGHT BOOKS
CINCINNATI, OHIO

How to Draw Portraits in Colored Pencil From
Photographs. Copyright © 1997 by Lee Hammond.
Manufactured in China. All rights reserved. No part of this book
may be reproduced in any form or by any electronic or
mechanical means including information storage and retrieval
systems without permission in writing from the publisher,
except by a reviewer, who may quote brief passages in a review.
Published by North Light Books, an imprint of F&W
Publications, Inc., 1507 Dana Avenue, Cincinnati, Ohio 45207.
(800) 289-0963. First paperback edition 2000.

Other fine North Light Books are available from your local
bookstore, art supply store or direct from the publisher.

04 03 02 01 00 5 4 3 2 1

Library of Congress has catalogued hard copy edition as
follows:

Hammond, Lee.
 How to draw portraits in colored pencil from photographs /
Lee Hammond.
 p. cm.
 Includes index.
 ISBN 0-89134-762-3 (hardcover)
 1. Portrait drawing—Technique. 2. Colored pencil drawing—
Technique. 3. Drawing from photographs—Technique. I.
Title.
NC892.H36 1997
743'.4—dc20 96-38854
 CIP
ISBN 1-58180-099-1 (pbk.: alk. paper)

Edited by Julie Wesling Whaley
Production Edited by Michelle Kramer
Interior designed by Jannelle Schoonover and Sandy Kent
Cover designed by Julie Martin

METRIC CONVERSION CHART

TO CONVERT	TO	MULTIPLY BY
Inches	Centimeters	2.54
Centimeters	Inches	0.4
Feet	Centimeters	30.5
Centimeters	Feet	0.03
Yards	Meters	0.9
Meters	Yards	1.1
Sq. Inches	Sq. Centimeters	6.45
Sq. Centimeters	Sq. Inches	0.16
Sq. Feet	Sq. Meters	0.09
Sq. Meters	Sq. Feet	10.8
Sq. Yards	Sq. Meters	0.8
Sq. Meters	Sq. Yards	1.2
Pounds	Kilograms	0.45
Kilograms	Pounds	2.2
Ounces	Grams	28.4
Grams	Ounces	0.04

DEDICATION

This book is dedicated to my mom, Mrs. Dorothy Hagen, who deserves much of the credit for helping me become the person I am today. I know it was no easy task raising me. Thank you Mom, for all you've done to support me, even when I was making *huge* mistakes. You've always been there, no matter what, and for that I will always be grateful.

The proudest day of my life was my first booksigning, with you there beside me. I love you!

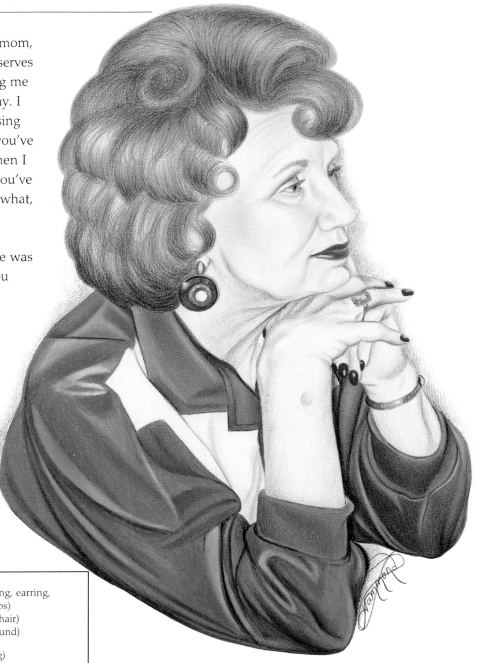

Dorothy (Dolly) Hagen
16″ × 20″ (41cm × 51cm)

Pencils used:	Prismacolor (clothing, earring, fingernails and lips) Verithin (skin and hair) Col-erase (background)
Technique:	Burnished (clothing) Layered (skin and hair) Blended (background)
Surface:	Mat board no. 1008, Ivory
Sealant:	Workable fixative
Colors:	<u>Prismacolor</u> . . . True Blue, Light Aqua, white, Crimson Red, Indigo Blue <u>Verithin</u> . . . Flesh, Terra Cotta, Sienna Brown, Dark Brown <u>Col-erase</u> . . . black

ABOUT THE AUTHOR

Polly "Lee" Hammond is an illustrator and art instructor who operates a busy teaching studio in the Kansas City area. After living all over the country, she has once again settled in Kansas, which she calls home.

She was raised and educated in Lincoln, Nebraska, where she still continues to teach on a regular basis. She built her career in illustration and art instruction in Kansas City. She now travels and teaches seminars in a variety of art techniques and mediums including two seminars a year at The Village Gallery of Arts in Portland.

Lee is continuing to create art instruction books, and is also expanding her writing into short stories and children's books, which she also illustrates.

Lee is the mother of three children, Shelly, LeAnne and Christopher. She also has a granddaughter, Taylor Marie.

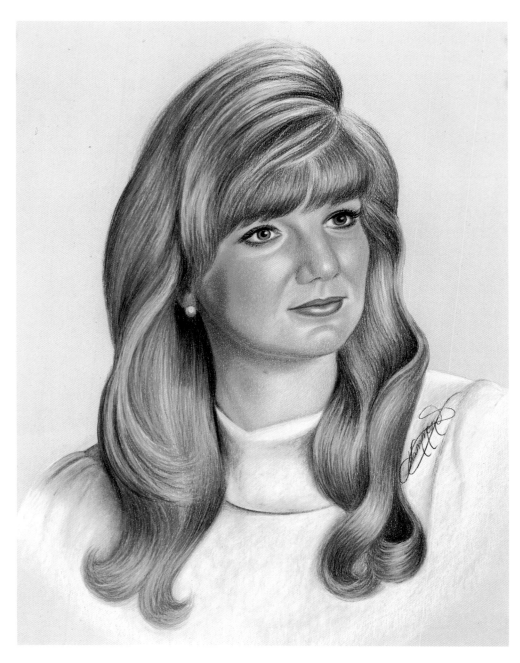

Self-portrait of author
*Prismacolor on no. 1014
Olde Grey mat board.
12" × 16"
(30cm × 41cm)*

ACKNOWLEDGMENTS

Writing a book is not an easy job. Writing *and* illustrating a book is even harder. So many things play a part.

It requires time, which is hard to find in this day and age. It requires thought, which is a hard thing to focus when life bombards you minute by minute with endless challenges. It requires knowledge, derived from years and years of fragmented, hit-and-miss experiences. But most of all, it requires *love*. Love for what you are doing and love as a foundation and support system.

I have experienced love of the purest form due to the writing of my books. I have seen my family sacrifice and endure as I concentrated more on my books than on them. I have seen my friends back me up when stress took its toll and revealed a side of me better left unseen! I have been fortunate to have sisters who are in a similar line of work and teaching to confide in, and who can relate to the "artistic personality," and a brother who can understand the need to combine "succeeding" with a good quality of life.

I want to thank the wonderful people at North Light Books, who have once again trusted in my abilities to create a book worthy of the North Light name. The opportunities they have given me have expanded my career further than I had ever imagined. Thank you Julie

Whaley, for your patience and expert editorial input.

Thank you also to people I have worked with at Sanford-Berol, who have allowed me the opportunity to demonstrate the Prismacolor products for them. A special thanks to Tom Edgeworth for opening so

many doors for me.

A heartfelt thank-you goes to Laura—just for being you.

And a very special thanks to Dr. Wayne Dyer, who unknowingly but profoundly changed my life. None of my books would exist if not for you.

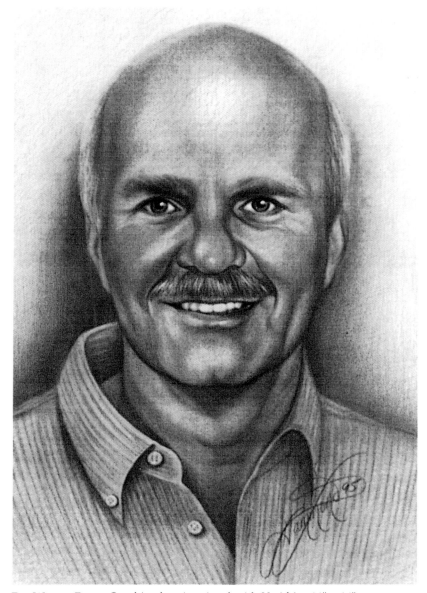

Dr. Wayne Dyer, *Graphite drawing tinted with Verithin, 11" × 14" (28cm × 36cm)*

CONTENTS

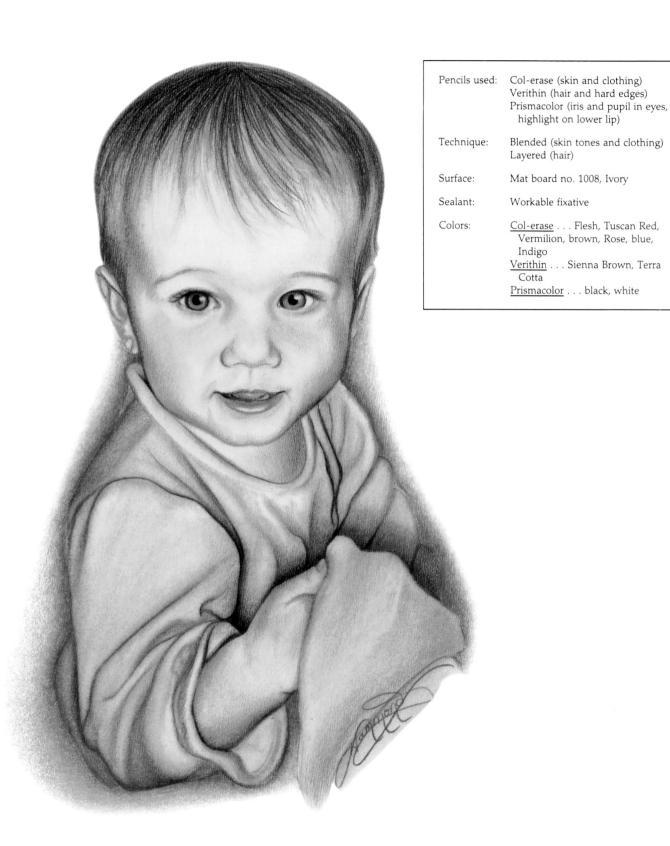

Pencils used:	Col-erase (skin and clothing)
	Verithin (hair and hard edges)
	Prismacolor (iris and pupil in eyes, highlight on lower lip)
Technique:	Blended (skin tones and clothing)
	Layered (hair)
Surface:	Mat board no. 1008, Ivory
Sealant:	Workable fixative
Colors:	Col-erase . . . Flesh, Tuscan Red, Vermilion, brown, Rose, blue, Indigo
	Verithin . . . Sienna Brown, Terra Cotta
	Prismacolor . . . black, white

Taylor Marie, my first grandchild
16" × 20" (41cm × 51cm)

INTRODUCTION

In my first book, *Drawing Lifelike Portraits From Photographs*, I concluded with the question, "Where do we go from here?" For me as an artist, I wanted to do it all! I struggled to learn every medium, every technique, every style imaginable, to discover my personal favorites. I wanted to be sure that if I had to turn work down, it was because I was too busy, not because I didn't know how to do the project. It took many, many years to feel proficient at so many techniques, but I now feel fortunate for the versatility.

Although I still have the desire to "do it all," I have narrowed things down somewhat to the mediums and techniques that I enjoy the most. Colored pencil is one of those mediums.

Versatility is a good word to describe colored pencil. Few mediums offer the range of looks, styles and techniques that colored pencil offers its user. Many of the pieces I would once do in graphite, for instance, I now do in colored pencil. Many of the pieces I would once do in oil, I now do in colored pencil. Amazing!

This book, although it focuses on portraiture, will show you many ways to apply colored pencil. The styles and techniques will vary from illustration to illustration, giving you the option of selecting the look or technique that appeals the most to you and your style of drawing. Although I will cover the shapes of the individual facial features, this book will focus mainly on technique. For more involved study of the facial anatomy, you may want to refer to my first book, *Drawing Lifelike Portraits From Photographs*.

The questions asked in this book are from actual students I teach, with the answers explained in step-by-step detail. I am promoting the pencils that I like and demonstrate the most—Prismacolor, Verithin and Col-erase. Color names and numbers will be used whenever possible for your convenience.

Some of the illustrations in this book will be explained with an *info box*. It will detail for you (1) the type of pencils used, (2) the technique used to achieve its particular look, (3) what type of paper the drawing is on, (4) which final sealant was used and (5) the list of colors. By having this information provided, you can study each illustration and see how it all went together.

Have fun and experiment. Colored pencil has a definite feel to it when handled properly. My first encounters were somewhat frustrating, but given time, skill does develop. Be persistent. You can do it! You won't be disappointed!

CHAPTER ONE

YOU CAN DO IT!

As I said in the introduction, colored pencil has a definite feel to it. As a beginner, you may have some frustration when trying to use it, which is perfectly normal. It is not unusual for your first attempts to look childish, as if the drawing was done in crayons rather than good quality art pencils. This will pass as you learn to hold the pencil properly and apply it in the correct fashion. The following are some typical examples by students, and the problems they experienced. As you will see, a little understanding of the medium and some practice can really pay off! You too, will have these wonderful results if you follow the directions in this book and practice. The more you do, the better you will become. You will acquire the right feel that will result in a firm control of what you're doing. Practice, practice, practice. You can do it!

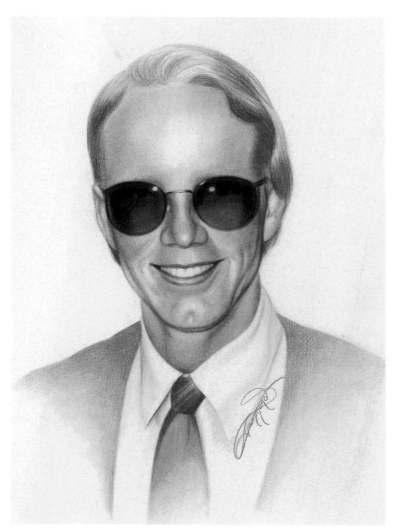

Pencils Used:	Col-erase
Technique:	Blended
Surface:	no. 915 Fog mat board
Sealant:	Workable fixative
Colors:	Brown, Flesh, Tuscan Red, Carmine Red (skin tones) black, brown, Tuscan Red, Flesh, white (sunglasses) brown, Tuscan Red, Canary Yellow (hair) black, Light Gray, Light Blue (suit and shirt) Carmine Red, Tuscan Red (tie)

William David Hagen III
12" × 16" (30cm × 51cm)

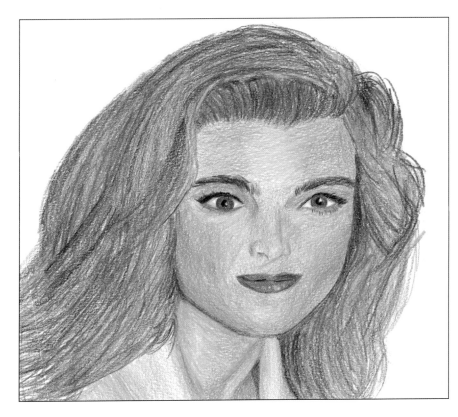

This is a typical beginner's drawing. Rather than looking smooth and controlled, the drawing has a crayon appearance. By using white paper, the small white spots throughout the color really stand out. The proper colors have not been used, which makes the skin tones look muddy, and the hair looks unreal. The features, although at an angle in the photo reference, have been straightened out (a common error). This made the likeness impossible.

Student's first attempt at Colored Pencil.
Artist: Marcia Fullmer

Look at the improvement a few lessons made. Compare the skin tones. Not only are the colors more believable, but the control over the medium is now obvious. By using an Ivory colored paper and keeping a sharp point on her pencils, you no longer see the white spots; the skin now seems smooth.

The face was graphed for proportion, and the proper angle was achieved. Now the likeness is there, and the realism. Also, notice how much nicer the hair appears. By using the right colors and taking the time to fill it in, it looks much more like real hair.

Note: Her first drawing was done in Prismacolor pencils. For the second drawing, I had her change over to Verithin. It is an easier technique to learn.

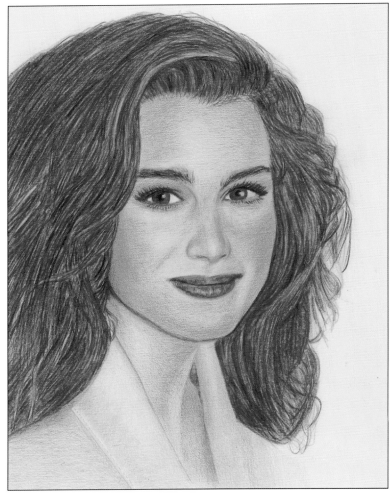

Revised student drawing.
Artist: Marcia Fullmer

Before and After

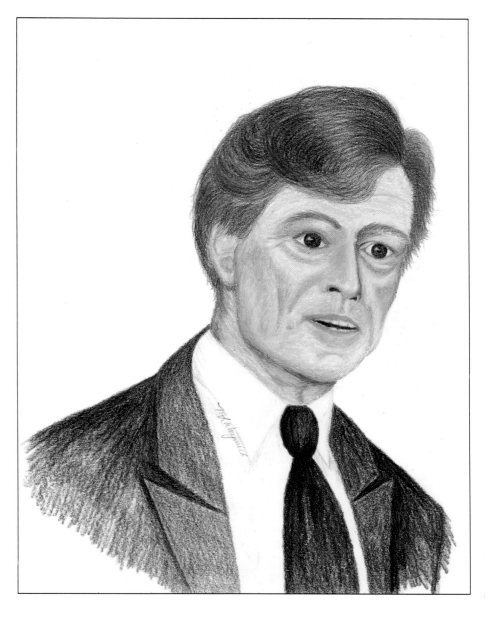

Drawing of Robert Redford (first attempt).
Artist: Mary Lou Waymire

This was this artist's first attempt at using colored pencils. This drawing shows many of the problems beginning artists face when trying colored pencils for the first time.

Many of the problems are created because of our childhood relationship with crayons. Our memory tells us to just fill in the color, instead of layering and controlling the pencils. The results are an uneven, unfinished looking drawing.

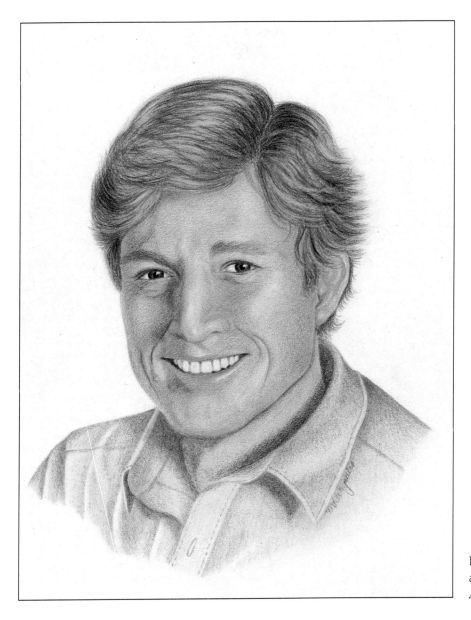

Drawing of Robert Redford (second attempt).
Artist: Mary Lou Waymire

This drawing shows what happens when the artist understands the procedures for applying the colored pencils properly. Now the colors look smooth and realistic. By further studying the shapes of the features, the likeness is much more evident than before.

Don't Give Up!

You may be thinking to yourself, "This is all too hard for me," or "too confusing." You may believe that your drawings will always look like the "before" examples. Believe me, I felt that way too. As a matter of fact, I gave up colored pencils for a while because I just couldn't get them to perform. But I didn't give up and neither should you!

I'll start you out with easy exercises, designed to introduce you to the feel of colored pencil with slow, steady progress. It will be fun. Don't get frustrated! In no time at all, you too will be drawing with colored pencil like a pro. If you have the desire, I have the way.

Don't get frustrated! *11" × 14" (28cm × 36cm)*

Pencils:	Col-erase (skin, clothing and hair bow) Prismacolor (eyes, hair, eyebrows, shadow areas and hard edges)
Technique:	Blended (skin tones and clothing) Layered (hair)
Surface:	Mat board no. 912 (India)
Sealant:	Workable fixative
Colors Used:	<u>Col-erase</u> . . . black, Tuscan Red, Light Green <u>Prismacolor</u> . . . black

GETTING STARTED

Using the Proper Pencils

Each brand of pencil has a different appearance when used. Each one has its own characteristics and good qualities. Experiment with different pencils to see which ones you like best. For simplicity, I have limited my discussions in this book to three kinds of colored pencils I use often. Rarely will I do my drawings with just one type. I generally use at least two types, if not all three, because any one by itself is limited in its ability to produce the desired look.

Prismacolor

These pencils have a thick, soft lead, which provides a smooth feel and, when applied heavily, will completely cover the paper surface. Colors can be easily blended. I use these when I want extremely bright colors, smooth textures or deep dark areas. They come in the largest number of colors, 120 to date.

Verithin

These pencils have a harder, thinner lead than the Prismacolors. They have a less waxy consistency and can be sharpened to a very fine point. The colors are compatible with the Prismacolors, but are limited in number, forty-eight to date. I use Verithins whenever I want the paper surface to show in my work, since they will not give you complete, heavy coverage. I use them for very light drawings or for texture areas such as skin and hair. Colors can be layered without smearing. They are also good for giving sharp, precise lines.

Col-erase

Unlike Prismacolor and Verithin, this pencil can be erased. It also can be blended with a stump or tortillion, giving it a soft pastel look. These pencils have a smaller range of colors, twenty-four to date, but can be blended together easily. They too can be sharpened into a fine point, but due to their powdery consistency, it is hard to achieve extreme darks. Left unsprayed, they resemble pastel. Sprayed with fixative, they look like watercolor.

Before beginning any drawing, you must determine what look you want your finished piece to have.

PRISMACOLOR
This value scale was done in Dark Brown. You can see how deep the color is. The lighter area is achieved by lightening your touch.

VERITHIN
This value scale was done in Dark Brown also. You can see how much lighter the appearance is. It does not cover the paper surface as completely as the Prismacolor. By using a lighter touch, you can get a much softer light area, where it fades into the paper.

COL-ERASE
Brown was used for this value scale. After the pencil was applied, it was blended out with a tortillion until it faded into the paper. It takes on a pastel appearance.

Colors

When drawing faces and portraits in colored pencil, the colors you use will vary from picture to picture. Not only does every individual have a different skin tone, other factors must be considered. Color reflects and bounces and is affected considerably by lighting. It is imperative that you closely study the photograph before you begin to work, to fully understand how the colors are reacting in that picture.

Although every picture is different, you will find yourself using many of the same colors again and again. On the next page you'll see a combination of colors I use frequently. You may use just a few of these colors, or you may use colors not on this list. This is merely a guide to help you find a formula.

The Prismacolor color swatches have been drawn on three different colors of paper backgrounds. Notice how the colors drawn on black paper seem much lighter than those drawn on the white, even

though they are the same color. It is important to test your colors when selecting papers to draw on.

Because of the lighter pigmentation of the Verithin and Col-erase pencils, I drew them on a lighter paper. However, there are endless possibilities for changing their looks by the color of paper you choose.

PRISMACOLOR Light Skin Tones

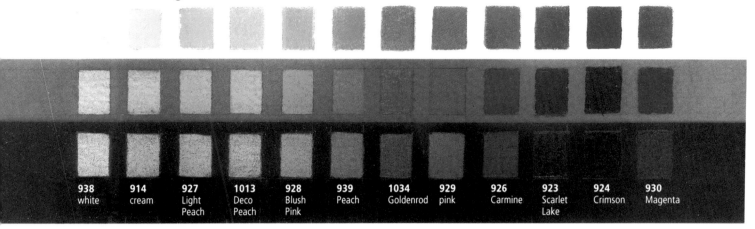

| 938 white | 914 cream | 927 Light Peach | 1013 Deco Peach | 928 Blush Pink | 939 Peach | 1034 Goldenrod | 929 pink | 926 Carmine | 923 Scarlet Lake | 924 Crimson | 930 Magenta |

Dark Skin Tones

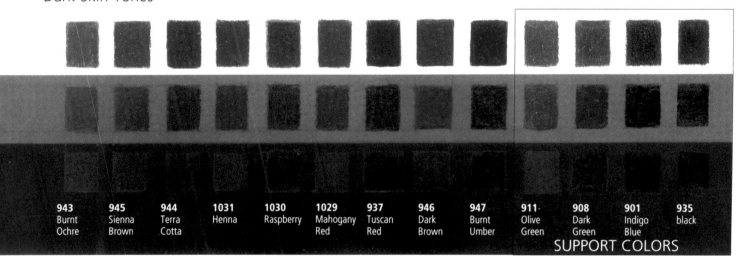

| 943 Burnt Ochre | 945 Sienna Brown | 944 Terra Cotta | 1031 Henna | 1030 Raspberry | 1029 Mahogany Red | 937 Tuscan Red | 946 Dark Brown | 947 Burnt Umber | 911 Olive Green | 908 Dark Green | 901 Indigo Blue | 935 black |

SUPPORT COLORS

VERITHIN

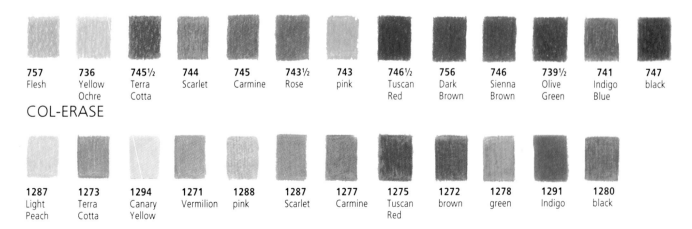

| 757 Flesh | 736 Yellow Ochre | 745½ Terra Cotta | 744 Scarlet | 745 Carmine | 743½ Rose | 743 pink | 746½ Tuscan Red | 756 Dark Brown | 746 Sienna Brown | 739½ Olive Green | 741 Indigo Blue | 747 black |

COL-ERASE

| 1287 Light Peach | 1273 Terra Cotta | 1294 Canary Yellow | 1271 Vermilion | 1288 pink | 1287 Scarlet | 1277 Carmine | 1275 Tuscan Red | 1272 brown | 1278 green | 1291 Indigo | 1280 black |

Organizing and Using Colors

Warm Colors include yellow, yellow-orange, orange, red-orange, red and red-violet. Warm colors will always appear to come forward.

Cool Colors include yellow-green, green, blue-green, blue, violet and purple. Cool colors will always appear to recede, so use them in shadow areas.

Colors can also be grouped into opposite colors, or complementary colors. Red and green, blue and orange, and yellow and violet are all examples of opposite colors. By placing these colors together, they make each other stand out. You can use an opposite for shading. For instance, instead of using black, which will dull a color, use the color's opposite to darken shadow areas. In this sphere example, the first red sphere was shaded with green. See how the green darkened the red without taking the color over? In the second sphere, I used black over the red, and the red

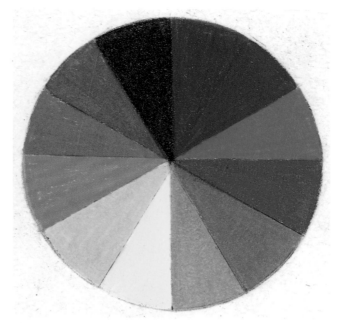

Warm colors

Cool colors

The color wheel is one way to group and categorize colors. This color wheel is made up of twelve colors. The six on the left are warm colors, and the six on the right are cool colors.

seems much duller because the black is so much darker and competes with the red. Opposites, on the other hand, are closer in tone and work together.

I use opposite colors frequently in this book, both as a way of shading and as a way of enhancing colors to make them appear more vivid.

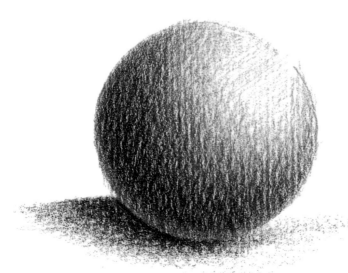

Red shaded with green, its opposite.

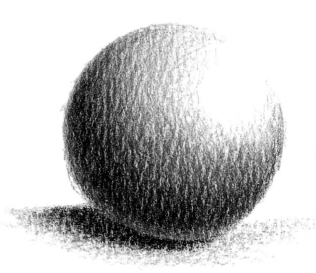

Red shaded with black.

The Right Tools for the Job

As with any art technique, the quality of your work is contingent upon the products and tools you use. The following list of materials will help you select the things you need to succeed with colored pencil.

Paper

Besides the pencils themselves, the paper you use is extremely important. There is a variety of fine art papers on the market today. You have the option of choosing from hundreds of sizes, colors and textures. We all have our own preferences. I am mentioning my personal favorites and the reasons I like them. However, I think part of the fun in drawing is experimenting with different papers.

Before I select a paper, I always check the weight. Although there are many beautiful papers available with attractive colors, I will only use a paper that is heavy enough not to bend or crease too easily. I had to learn this the hard way. There is nothing more disappointing than completing a beautiful drawing and having noticeable buckles and creases in the paper surface that attract your attention more than the artwork itself. For this reason, I only use paper that is rigid.

Strathmore has several papers I often use.

Artagain

This is a recycled paper with a flannel appearance. It is a smooth 60 lb. cover-weight paper. It comes in a variety of "dusty" colors, including black and white, and has a speckled look to it. It has no texture. It is available in pads and large single sheets for bigger projects.

Colored Art Paper

This is a very rigid, 65 lb. paper that has a texture to it. It comes in pads of rich, deep colors and some nice neutrals. Due to the texture, you can create some nice looks with your colored pencils. It is of good quality and is fade resistant.

Renewal

This is another rigid, smooth paper. It has a similar feel to the Artagain paper, but has the look of small fibers in it instead of speckles. I like it for its soft earth tones. It is available in large single sheets.

Cresent Mat Board

This is my favorite surface to work on due to its firmness. It does not require being taped to a drawing board and it is easily transported. Its wide range of colors and textures is extremely attractive. It is fun to match your subject matter to the selection of mat boards available. When framing my piece I often use the same color of mat board to keep it color coordinated.

I rarely use a white paper when working with colored pencil. My two favorite colors are no. 1008, Ivory (a warm, creamy color that enhances skin tones) and no. 916, Autumn Mist (a soft, cool gray that's beautiful when working in black and white or gray tones).

Pencil Sharpeners

To properly handle and control colored pencil, you must always have a sharp point. (I will explain this more in the following chapter.) I prefer an electric sharpener or a battery-operated one when I am traveling. These sharpen the pencil straight without you having to twist it. The twisting motion breaks most pencils when using a handheld sharpener. If you prefer the handheld type, spend the extra money to get a good stainless steel one. It will last longer and will usually come with replacement blades.

Erasers

I suggest having three erasers when working with colored pencil: a kneaded, a Pink Pearl and a typewriter eraser.

Although colored pencil itself is not easy—if not impossible—to erase (except for the Col-erase pencils), there will be times when you will need an eraser.

The kneaded eraser is a squishy, clay-like eraser, good for removing the light graphite outlines in your initial sketch. It also can be used to lift highlights out when drawing with the Col-erase pencils.

The Pink Pearl eraser is a good eraser for general cleaning. I use it the most when I am working to clean up smudges and marks around my drawing. It is also good for cleaning up the background area when you are finished. It is fairly soft and will not hurt the paper surface.

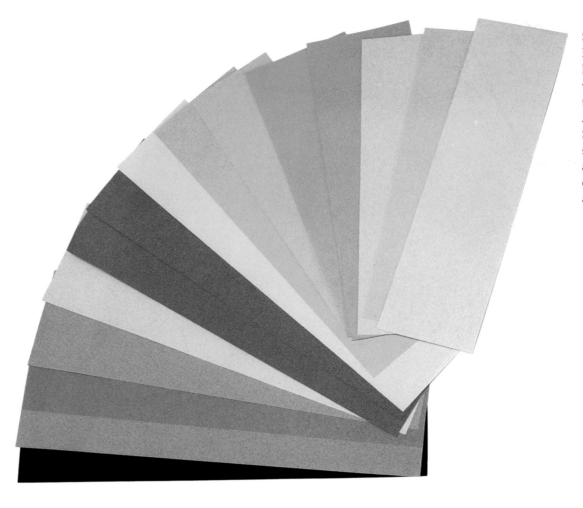

Strathmore Renewal paper has soft colors with the look of tiny fibers in it. Artagain, also by Strathmore, has a speckled appearance, and deeper colors. Both have a smooth surface.

The typewriter eraser looks like a pencil. It is good for tough jobs and stubborn marks that cannot be erased with the Pink Pearl. It is highly abrasive in nature, and great care must be taken or you can damage your paper surface by rubbing too hard. It is a good eraser to use when you need to get along an edge or into tight places. It can be sharpened to a point, but a tip that is too sharp will become too flimsy to use.

Mechanical Pencil

I always begin my drawings with a very light pencil outline or sketch.

To be sure that the pencil lines will be light and easily erased as I apply the colored pencil, I always use a mechanical pencil. The very fine point and thin lead prevents the lines from being too dark, unlike that of an ordinary drawing pencil. The lines can be easily erased with the kneaded eraser.

Tortillions

These are cones of spiral-wound paper. They are used to blend the colors on your paper. While used more often for graphite, charcoal or pastels, I use them to blend the Col-erase pencils.

Graphs

These acetate slipcovers divide your photo reference into even increments, making it easier to draw with accuracy. They can also be used to enlarge or reduce your photo. You will need to make one with half-inch squares and one with one-inch squares on it.

Templates

To obtain a perfect circle or ellipse, it is always better to use a stencil or template. I use these when drawing eyes to get the shapes of the iris and pupil.

Magazines

This will be your best source of subject matter while you are learning. I tear the pictures out of the magazines and place them in files for later use. Glamour magazines will give you the biggest, clearest, full-page faces to practice from.

Ruler

You will need a good ruler for drawing graphs, both on the acetate and on your drawing paper.

Permanent Fine Point Marker

This is used to draw the lines on your acetate graph.

Craft Knife

Craft knives are not just for cutting things. They can actually be used as a drawing tool. Sometimes I will use the craft knife to gently scrape off a color, since colored pencil is not easily erased without smearing. By using the flat edge of the knife, you can scrape away unwanted areas or any specks that may have gotten into your work. A craft knife can also be used to create texture, such as hair or fur. In either case, you must be careful not to gouge the surface of the paper. (This will be explained further in chapter three.)

Horse Hair Drafting Brush

Whenever you are drawing, always have a drafting brush by your side. This is very important when you are working with colored pencil. When applying heavy layers of colors, colored pencil will have a tendency to flake or make crumbles. If you were to brush these particles off with your hand, you would risk smearing your work and ruining it. Since the bristles of the drafting brush are soft, they will not hurt your drawing. It should also be used when erasing.

Fixatives

The type of fixative you use depends on the final look you want your artwork to have. I use three types of sprays, each one having a completely different look. Of all the colored pencils, Col-erase is the brand most affected by fixatives. Its powdery finish is somewhat melted by the spray, giving it something of a watercolor appearance.

Workable Fixative

This is a light spray that is not noticeable when used. The term *workable* means that you can continue drawing after you have sprayed it on your artwork. Experience has taught me that this is more true when using graphite than colored pencil, however, and this fixative can almost act as a resistant. I use it as a final coating, especially when I don't want the appearance of my work to change. I use this spray mostly when working with Verithin or Col-erase, where I want to prevent them from smearing but do not necessarily want to glaze the surface.

Matte Finish

This is a spray that will completely seal the surface of the drawing. It often will intensify your colors, so be careful when spraying. The first application should be a very light mist to prevent the paper from becoming saturated. Because it is a matte spray, it will not produce any shine to your work. I use it the most when I am using Prismacolor. Because of the high wax content of Prismacolor, the drawing must be sealed when finished to prevent the wax from rising to the surface, which creates a foggy, milky look called a *bloom*. Matte finish will keep it from blooming, without making it look shiny.

Damar Varnish

I use this spray when I want a high gloss, intense look to my work. This is especially true when I want bright colors, since damar varnish will brighten dull colors. It is typically used for oil paintings, but makes colored pencil look beautiful. Although I use the other sprays more when doing portraiture, I often use this spray when drawing flowers, fruits and other brilliant subjects. Again, I use this spray mostly with Prismacolor.

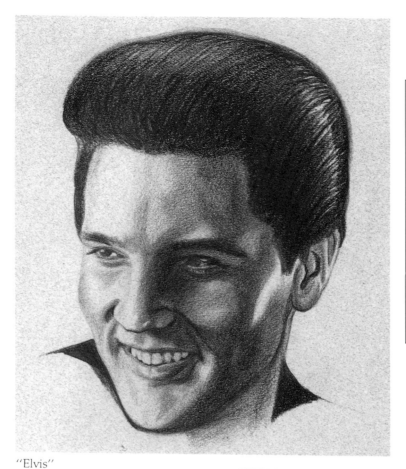

"Elvis"
Monochromatic in Verithin.
5" × 6" (13cm × 15cm)

Pencils used:	Verithin (Elvis no. 1)
	Prismacolor (eyes and hair of Elvis no. 1)
	Prismacolor (Elvis no. 2)
Technique:	Layered (Elvis no. 1)
	Burnished (Elvis no. 2)
Surface:	Artagain paper (Storm Blue)
Sealant:	Workable fixative
Colors:	black (Elvis no. 1) Verithin and Prismacolor
	Prismacolor . . . white, cream, Deco Orange, Light Peach, Burnt Ochre, Terra Cotta, Dark Brown, Tuscan Red, black and white. (Elvis no. 2)

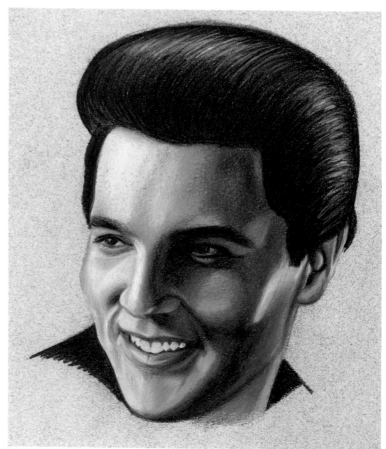

"Elvis"
Full color in burnished Prismacolor.
5" × 6" (13cm × 15cm)

Primary Transaction: 71122

Receipt: 71138

Wednesday Afternoon . 290
Cashier: Sales
Workstation: POS
Sale Date/Time: 23/05/2018 12:54:05
Customer: B WHITEHOUSE - 203207

£1 BK 1PM	6 @ £1.00	£6.00
-£1		1.00
-1p	19	0.01
1PM 5PG - 1PM5PG (6)	6 @	2.33
G.F.G	7 @ £1.00	£7.00
G.F.G - G.F.G (6)	7 @ £1.00	

Total: £13.00
Tendered: £0.00

CHAPTER THREE

TECHNIQUES

The look you achieve with colored pencil depends entirely on how you apply it, or the technique you employ. There are many approaches to colored pencil. I will show you the techniques that I use the most. The ones you use will depend on your own drawing style and your unique personal taste. Everyone is different, and one of the finest qualities of colored pencil is its versatility.

The illustrations on the left show you how two very different techniques were applied to the same subject matter. They differ not only in the way that the colored pencil was applied, but also in the color choices.

The first illustration of Elvis was drawn in a monochromatic color scheme, using black pencil only, on a gray-toned paper. A monochromatic color scheme uses only one color, or a group of colors that are all closely related. The layered look was achieved by maintaining a sharp point on my pencil, which allowed the surface of the paper to come through. This helped create the varying shades of gray. I controlled the blend by changing the pressure that I applied to the pencil, pushing harder for the dark area, and lightening my touch for the lighter tones. The face was drawn with a Verithin pencil, and the hair

DON'T
A dull point on your pencil will create a crayon-like appearance.

DO
A sharp point on your pencil creates a smoother, more controlled blend.

and darks of the eyes were drawn with a Prismacolor since Verithin would not get as dark as I needed.

Although some highlights in the hair were left out as I drew, I scratched some out later with a craft knife. This kept the hair from looking stiff and unnatural.

The second illustration of Elvis was done in full color, meaning I was trying to replicate the colors as they actually are in nature. I used a technique called burnishing with Prismacolor pencils. Using a very firm touch, the colors are blended, one on top of the other. A lighter color is always applied over the darker ones to make them blend together, or transition into one another. This gives the colored pencil a painted look.

Value Scales

The best way to familiarize yourself with the various techniques of col-

ored pencil is to practice drawing some value scales. This is a good beginning exercise to practice controlling the pencil and its color from dark to light.

It is easiest to start with the layered approach, using one color only so you can concentrate on getting that feel I have been talking about. A sharp point is important while you draw; a dull pencil will appear crayon-like.

I find that I hold the pencil closer to the tip when doing the dark areas. This way I can exert more pressure but not so much that I break the point. As I work toward the lighter areas, I gradually lighten my touch and hold my pencil further back from the tip. This helps me to touch the paper surface lightly, giving me a much smoother blend. Your blend should be gradual as it fades from dark to light. There should be no choppiness

A value scale using the layered technique. Black Verithin on Storm Blue Artagain paper.

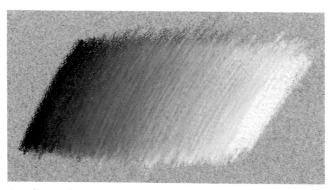
A value scale using the burnished technique. Black, Dark Gray, Light Gray and white Prismacolor.

where one tone ends and the other begins.

Practice many value scales. The more you do, the better you will become at controlling your pencils. Begin with a black colored pencil and then try other colors. Try blending one color into another or try using various paper colors to see how it affects the look of the pencil colors.

Once you feel comfortable with your ability to create a layered value scale, try some with the Prismacolor pencils and a burnished approach. Since you are completely covering the paper surface this time, you cannot use the paper to help create the blend. So, rather than using one pencil with varied pressure, you will need a range of pencils from black to white.

Lay out the colors, beginning with the black, then the dark gray, light gray and white. Overlap your colors as you go, using the lighter color to blend into the darker one. You may have to blend over and over, adding more dark or more light until it appears smooth. This is the only time you should let the tip of your pencil become dull.

Value Scale Spheres

The next step is to understand how the value scale is applied to a rounded surface. Drawing and shading the sphere is the most important lesson to learn since all of its principles apply to the face and create the realism you are trying to achieve.

The following step-by-step exercises will show you how to complete a sphere in gray tones using the techniques of layering and burnishing.

Edges

Another important element to practice on spheres is called soft and hard edges. Never do you use a hard outline to describe your subject. Outlining produces a cartoon effect. A line is only used when there is a hard edge. This is found where two surfaces touch or overlap. Then a crisp edge is created. On the sphere, a hard edge can be seen where the sphere and the table touch. Notice that you *do not* see a hard outline around the entire sphere. If there were one, it would look like a circle or disc, not a sphere.

A soft edge is where an object gently curves. It describes roundness by the shadow edge that is created. Soft and hard edges are what make up realism in your work. As we advance to more difficult subject matter, always ask yourself where the soft and hard edges are.

When you have created a hard edge, it is very important that it does not look like an outline. By softening the tones away from the edge, the illusion of continuous tone from dark to light is created, rather than an outlined surface that has been filled in.

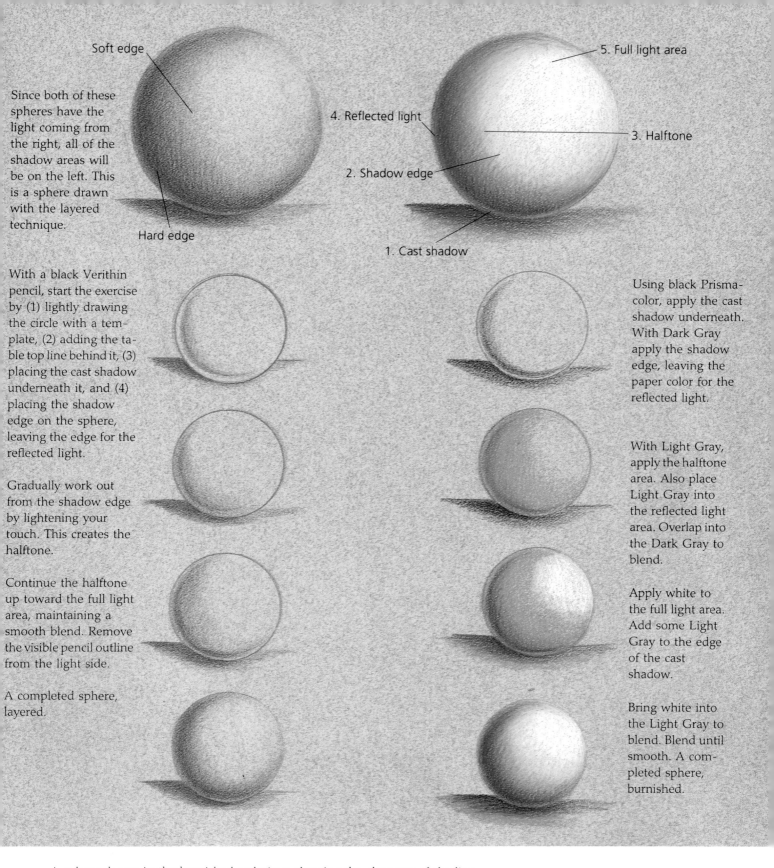

Soft edge

Since both of these spheres have the light coming from the right, all of the shadow areas will be on the left. This is a sphere drawn with the layered technique.

Hard edge

5. Full light area

4. Reflected light

3. Halftone

2. Shadow edge

1. Cast shadow

With a black Verithin pencil, start the exercise by (1) lightly drawing the circle with a template, (2) adding the table top line behind it, (3) placing the cast shadow underneath it, and (4) placing the shadow edge on the sphere, leaving the edge for the reflected light.

Gradually work out from the shadow edge by lightening your touch. This creates the halftone.

Continue the halftone up toward the full light area, maintaining a smooth blend. Remove the visible pencil outline from the light side.

A completed sphere, layered.

Using black Prismacolor, apply the cast shadow underneath. With Dark Gray apply the shadow edge, leaving the paper color for the reflected light.

With Light Gray, apply the halftone area. Also place Light Gray into the reflected light area. Overlap into the Dark Gray to blend.

Apply white to the full light area. Add some Light Gray to the edge of the cast shadow.

Bring white into the Light Gray to blend. Blend until smooth. A completed sphere, burnished.

A sphere drawn in the burnished technique showing the elements of shading:
1. Cast shadow—the darkest dark, the shadow cast by the object itself.
2. Shadow edge—creates the roundness, always opposite the light source.
3. Halftone—the true color of the object, between shadows and light.
4. Reflected light—light reflecting on the edge from behind and beside.
5. Full light area—where the light is strongest.

Sphere Exercises to Try

This sphere and value scale were drawn with an Indigo Blue Col-erase pencil. I used a tortillion to blend the tones out. To draw this sphere, follow the same directions as for the Verithin exercise, but rather than achieving a blend with the pressure of your pencil, use a tortillion to soften the tones into the light area. The nice thing about Col-erase is that if you get too dark in an area, you can use your kneaded eraser to lighten it.

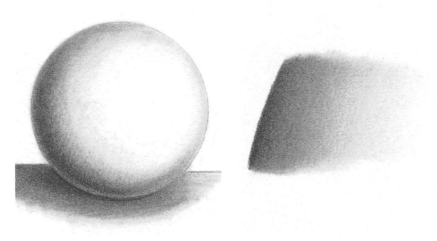

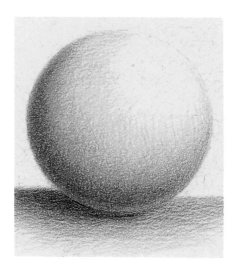

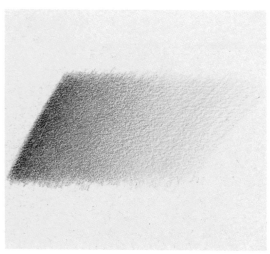

This sphere and value scale were drawn using Verithin pencils in flesh tones. I used Strathmore shell renewal paper, which enhances the flesh tones. The colors used are black, Dark Brown, Tuscan Red, Terra Cotta and Flesh. Notice how the colors are overlapped into one another, for a smooth gradual transition. Go slowly and don't get too dark too fast because you won't be able to erase it (although you can gently lighten it with a type-writer eraser).

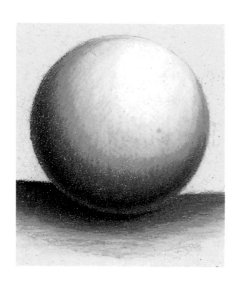

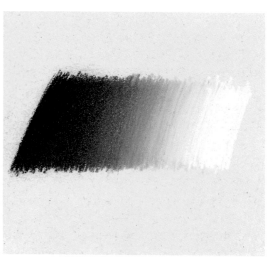

These examples are done with the flesh tones once again, but this time with the Prismacolor pencils. The colors used are black, Dark Brown, Tuscan Red, Terra Cotta, Flesh, cream and white. After the colors are layed down, the light colors always go into the dark colors to blend them together. Many layers can be added until you get the color and blend that you need.

Different Techniques to Try

Try drawing many spheres using different color combinations. By experimenting with all three types of pencils and different paper colors, you can begin to see which style and technique most appeals to you before you begin a big project.

When you are completely finished with your drawing, you will want to spray it with fixative. While Verithin and Col-erase could be left unsprayed if placed under glass, Prismacolor should always be sprayed. Because of the wax content of the pencils, wax rises to the surface of your drawing, causing the colors to lose their brilliance and appear milky and dull. Fixative must be used to prevent this from happening.

Just like these spheres, one face can have many looks depending on the type of pencils and the technique you decide to use. Look on the next page. Which style will become your favorite?

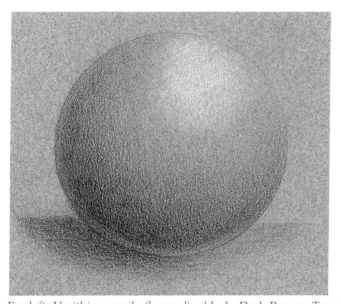 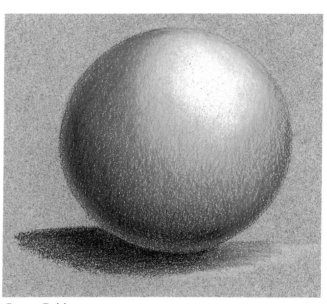

Far left: Verithin pencils (layered)—black, Dark Brown, Terra Cotta, Golden Brown and white. Left: Prismacolor pencils (burnished)—same colors. Both drawings drawn on Strathmore Steel Gray Artagain paper.

One Face, Four Looks

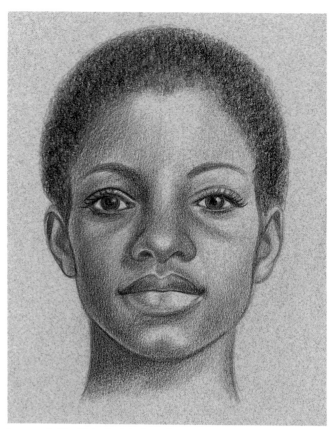

Layered, Verithin in black only.

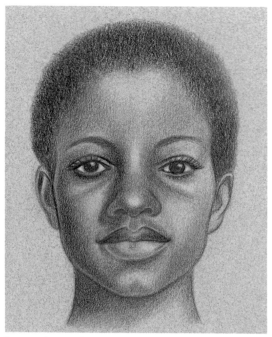

Layered, Verithin in a monochromatic scheme. Black, Indigo and green

Blended, Colerase in full color. Black, brown, Terra Cotta, Tuscan Red and Flesh

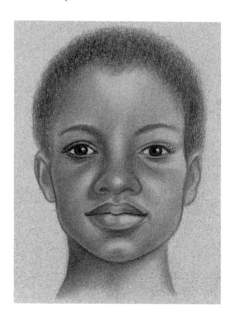

▶ Burnished, Prismacolor in full color. Black, Dark Brown, Tuscan Red, Terra Cotta, Burnt Ochre, Flesh, cream and white

CHAPTER FOUR

DRAWING THE NOSE

"John Lennon's Nose"
Prismacolor on white illustration board
(Layered technique).
9" × 12" (23cm × 30cm)

Colors: black, Indigo Blue, Mediterranean Blue.
Notice how the texture shows more when you
use the layered technique with Prismacolors in-
stead of Verithins.

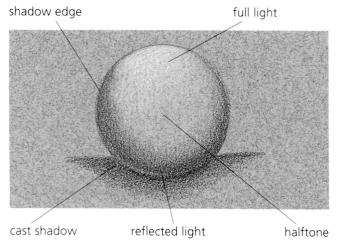

shadow edge · full light

cast shadow · reflected light · halftone

The sphere and the five elements of shading can be seen in the roundness of the nose.

Drawn with Verithin on Gothem Gray Artagain paper.
Colors: Dark Brown and white

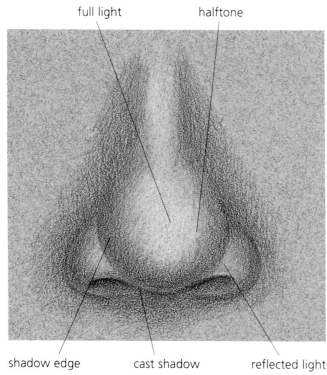

full light · halftone

shadow edge · cast shadow · reflected light

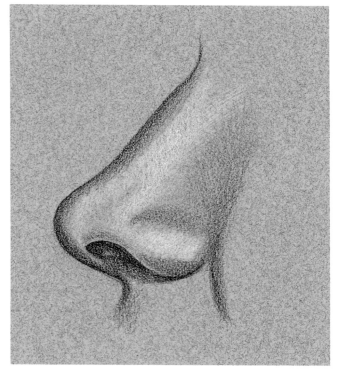

Drawn with Verithin.
Black and white on Gothem Gray
paper

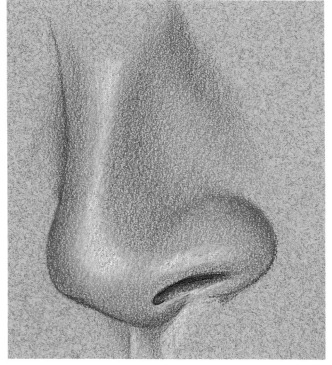

Drawn with Verithin.
Colors: Dark Brown, Tuscan Red, Terra
Cotta, Flesh and white
Gothem Gray paper

A Nose, Step-By-Step

You Try It

Always start simple. For this exercise, use only one pencil and practice the layering technique. This way you can fully concentrate on the feel of the pencil without having to change and worry about colors. It also gives you an opportunity to work on being accurate in your shapes.

I have provided you with a graphed line drawing to help you get started. Begin by very lightly drawing a graph with the same number of squares on your drawing paper. Since this drawing is in gray tones, I used a light gray paper, flannel white Artagain. Use your mechanical pencil, *not* your colored pencil for this, or you will not be able to erase the graph when you are done.

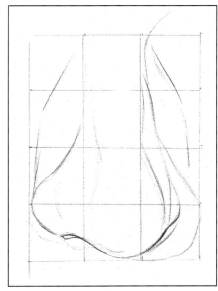

A graphed line drawing (for accuracy in shapes).

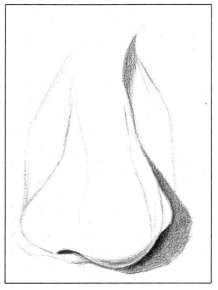

Step 1 START WITH SHADOW AREAS.

Start to draw the shape of the nose with the mechanical pencil. Study the shapes that are inside each square and draw them as accurately as you can. When you think you are as accurate as you can be, gently erase the graph with your kneaded eraser.

Next, take a black Verithin pencil, and with a very sharp point, begin placing the dark shadow areas as shown. Keep in mind the sphere exercise to help understand these areas of light and dark. Keep your tones as smooth as possible without allowing pencil lines to show. Remember to keep all your pencil lines going the same way.

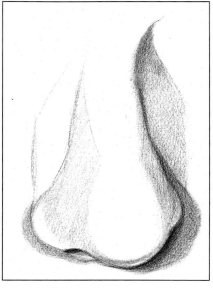

Step 2 CONTINUE WITH SHADOWS AND HALFTONE. (LIGHTEN YOUR TOUCH.)

Continue adding your darks and lightening your touch to add the halftones. Build it gradually and smoothly. Be sure to keep your pencil sharp!

A Nose, Step-By-Step (Continued)

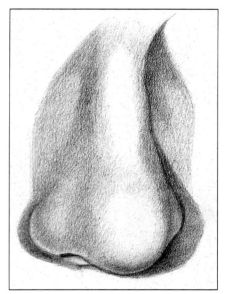 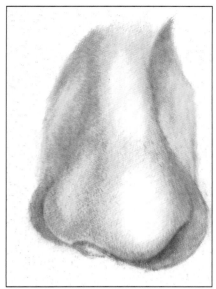 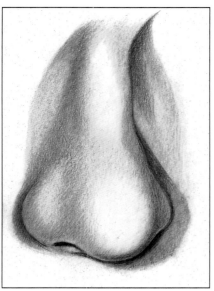

Step 3 A COMPLETED LAYERED DRAWING.

This is what the nose looks like completed with the layering technique. To see how to take this to a burnished look, follow the next two steps.

Step 4 COVER WITH WHITE PRISMACOLOR TO BURNISH. (REMEMBER, BURNISHING DOES NOT REQUIRE A REAL SHARP POINT.)

To practice the burnishing technique, you can simply add on to this drawing, or draw it again to the finished layered phase. Then take a white Prismacolor pencil and cover the entire drawing. Use firm pressure and be sure to get good coverage. It will change the color of the drawing and give it a dull, milky appearance.

Step 5 A COMPLETED BURNISHED DRAWING.

Add the darks back into your drawing on top of the white using a black Prismacolor. Use the white pencil to soften and blend the colors. Compare the two finished drawings. One style looks drawn and the other looks painted.

While a drawing done in Verithin will not require spraying with a fixative, a burnished Prismacolor drawing must be sprayed to prevent the cloudy wax bloom from rising to the surface.

Different Technique and Color

Now try a different color combination and a different technique. Do this exercise with the Col-erase pencils. (I used a peach-colored paper, shell renewal.)

Begin by placing your acetate, one-inch graph over the line drawing in the book. Using the mechanical pencil, draw a light graph on your drawing paper to match.

With a sharply pointed brown Col-erase pencil, begin placing the dark areas in the nostril. Continue placing dark values until they match the illustration.

To create the halftones with Col-erase, take a clean tortillion and gently blend out the tones. The powdery consistency of these pencils will make it easy to do. The light or highlight areas should remain the color of the paper.

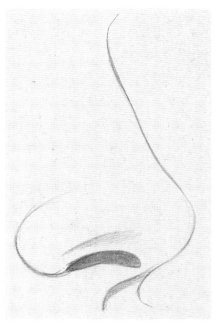

An accurate line drawing. The first dark areas have been applied with a brown Col-erase.

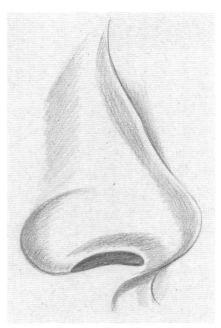

Continue applying the dark areas.

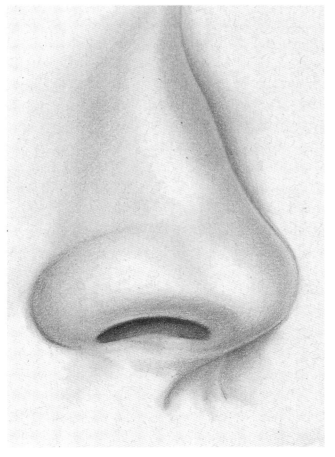

Blend with a tortillion to create the halftones and a smooth appearance. Leave the color of the paper for the highlight areas. A completed blended drawing.

Full Color, Step-By-Step

Now you are ready to try a drawing using full color. To help enhance the color of the skin, I have again chosen to use the peach-colored paper. This is always an important thing to consider before you begin to draw.

Take your acetate graph and replicate the graph and line drawing in step one on your drawing paper. Remember to use the mechanical pencil so you can erase the lines when you are finished. When you are satisfied with the accuracy of your line drawing, remove the graph with the kneaded eraser.

Shading

Begin shading the drawing with a Tuscan red Verithin. Be sure to erase the graphite lines as you go because graphite will interfere with the colored pencil by smearing into it and causing it to be muddy.

Fill the nostril area with the darkest tones. (This area is actually a cast shadow.) Place the shadow edge areas and continue on by building the halftones. At this stage you can see how the color of the paper plays an important part in portraying skin tones.

More Color

You must now add more color to finish the actual skin color. With a flesh-colored Verithin pencil, add some tone into the drawing. Overlap the flesh color into the Tuscan red. Be sure to keep your pencils sharp as you go and layer the colors slowly and gradually.

You could leave the drawing like this for a layered look, or you can continue on and burnish it for the painted look.

When you layer, you are allowing the paper color to become part of the drawing. It is important to transition the colors you are using gradually into the paper color by using a pencil similar in color to that of the paper. In this case, the transitioning color would be *flesh*.

Burnishing

To burnish, take the drawing and place an even layer of light peach Prismacolor over it. Like the black-and-white drawing that we did before, this will cause the colors to change, giving it a smooth, dull look.

Reapply the Tuscan Red to re-establish your dark tones. Continue adding colors to create skin tones, since we no longer have the color of the paper working for us. (We've covered it up!) I used peach and Salmon Pink to give it a warm, rosey pigment plus a little white for the highlights, all done with Prismacolor pencils. Be sure that you always soften the darker colors with the lighter ones. This is what makes the colors blend.

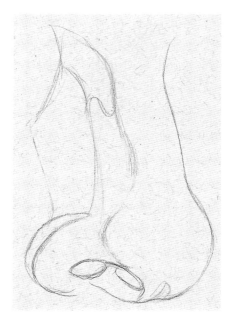

An accurate line drawing done with a mechanical pencil. Use a graph for accuracy in your drawing.

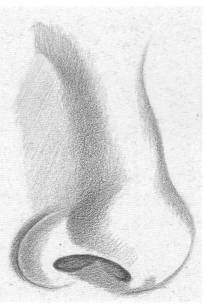

Start applying the dark tones with a Tuscan Red Verithin pencil. Allow the color of the paper to work with you to create the skin tones.

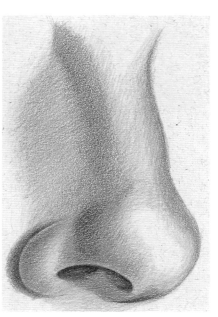

Add the color Flesh, overlapping into the Tuscan Red. Leave the paper color for the highlights.

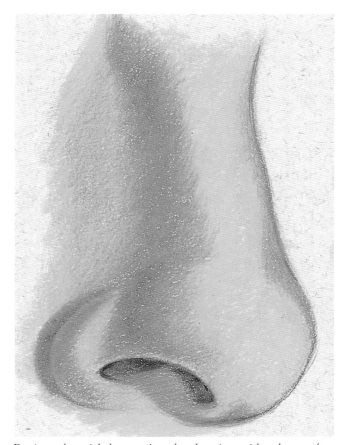

Begin to burnish by coating the drawing with a layer of Light Peach Prismacolor pencil.

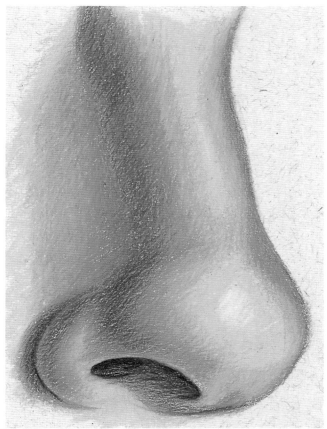

Strengthen your colors by reapplying the Tuscan Red to the dark areas. Add peach and Salmon Pink Prismacolor to create skin tones and white for the highlight areas.

CHAPTER FIVE

DRAWING THE MOUTH

Now that you're becoming familiar with the various techniques and types of colored pencil, it is time to move on to a more complex feature of the face, the mouth.

It is always easier to draw a closed mouth than an open one. We will begin with black and white. I will demonstrate both layering and burnishing. As you draw, look for the elements of shading that are created by the roundness of the lips. Because of the shape and the way the angles of the lips reflect light, the upper lip is usually darker than the lower lip. Although lips are darker than the rest of the face, *never* outline them. Anything with a hard line drawn around it will look like a cartoon.

Pencils used:	Prismacolor (subject) Verithin (background)
Technique:	Burnished (subject) Layered (background)
Surface:	Mat board no. 1008, Ivory
Sealant:	Damar varnish (to help the fabric of the dress look shiny, like satin)
Colors:	<u>Prismacolor</u> . . . Dark Brown, Tuscan Red, Terra Cotta, peach, Light Peach, cream and white (flesh tones) Tuscan Red, Carmine Red and white (lips) Dark Brown, Yellow Ochre and white (hair) Indigo, black and white (eyes) black, Light Aqua (dress) <u>Verithin</u> . . . Indigo, Dark Green and green (background)

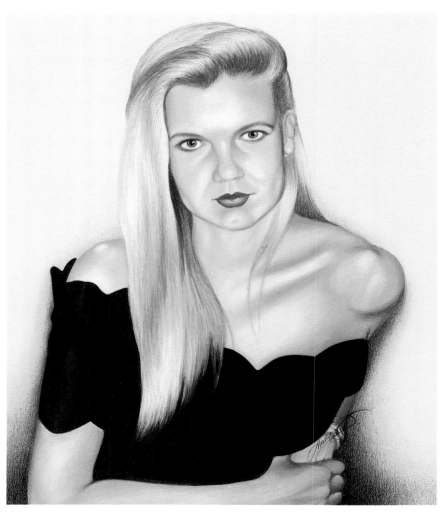

"Karin" 14"×12" (36cm×30cm)

Drawing Lips, Step-By-Step

Draw the graphed line drawing. Be accurate in your shapes.

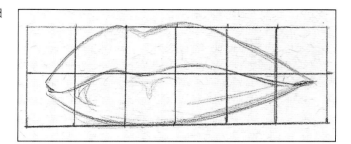

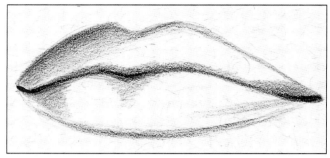

With a sharp black Verithin, add the darks to your drawing. Notice how the corners of the mouth (also called the pit) are dark and appear to "sink" into the face. It is also dark in the center where the two lips meet, creating a hard edge.

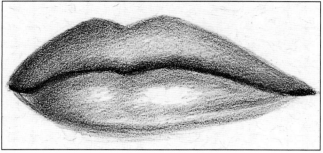

Gently add tone to the lips to create the depth of color, and the roundness and form. Look for the reflected light along the upper edge of the lower lip. Leave the paper color for the highlight areas. This drawing would be complete at this stage if using the layering technique only.

To burnish, cover the drawing with a coating of white Prismacolor.

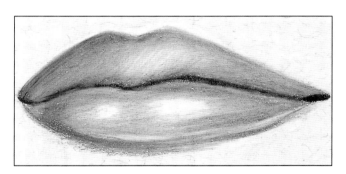

Reapply your darks with a black Prismacolor. Soften the tones together with the white Prismacolor until the tones are right and the blending is smooth.

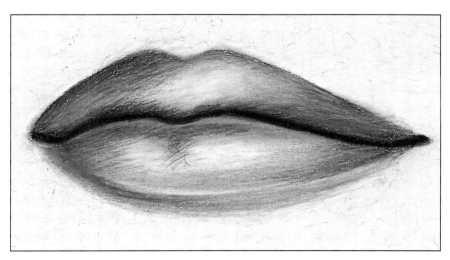

Drawing Teeth

Drawing the open mouth is much more of a challenge because of the accuracy needed in the placement, size and shape of each tooth. If this area of your drawing is not accurate, you will not be able to achieve a good likeness of the person you are drawing.

Using a smaller half-inch graph can help isolate the shapes for you into smaller, more workable pieces with less room for error. Take your time and study the shape of each tooth carefully.

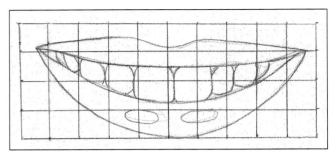

Be very careful about the accuracy in the shapes of the teeth. Do not overstate the line between each tooth. It is very subtle.

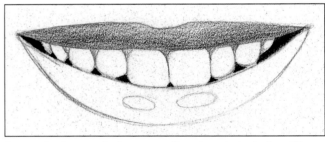

Begin shading with the upper lip, since it is darker. Use a black Prismacolor for the very dark areas, such as the corners of the mouth and under the teeth. (Verithin will not be dark enough.) Look at the gum line and the dark areas below the teeth as "puzzle piece" shapes. These shapes help create the shapes of the teeth. Be sure to apply the gum lines lightly.

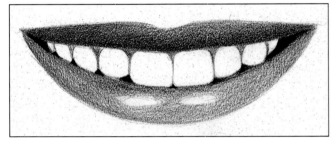

Add tone to the lower lip. Leave the white of the paper for the highlight areas. (Flannel White Artagain paper was used here.)

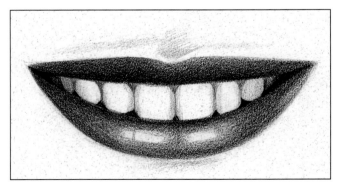

Strengthen your tones until they are dark enough, keeping the tones smooth and gradual. Place some shadows on the teeth for realism, with the back teeth being the darkest. This drawing would be finished at this stage if you were using the layering technique only.

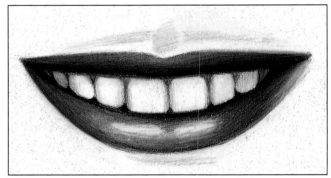

For the burnished look, cover the drawing with a coating of white Prismacolor. Reapply the dark areas with a black Prismacolor. Blend the tones together with the white again. Repeat the process until smooth and accurate in color.

Using Verithin

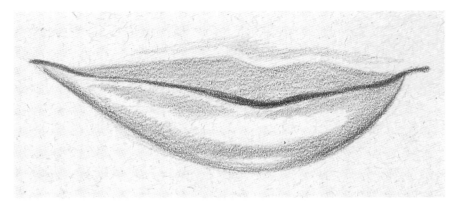

These lips are rendered on peach-colored paper using the Verithin pencils. After achieving a light, accurate line drawing with a graph, I replaced the graphite with a Tuscan Red Verithin. (It is important to remove all graphite.)

Add Flesh Verithin, overlapping into the Tuscan Red. Leave the color of the paper for the highlight area.

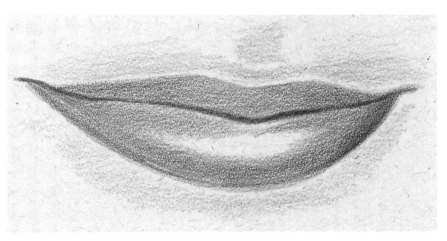

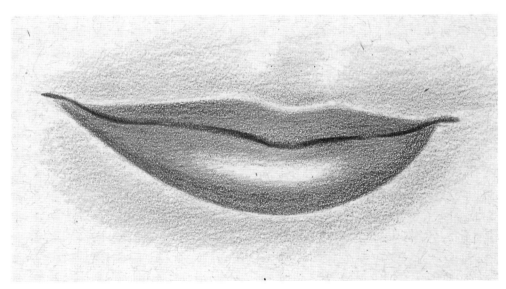

Intensify your colors. These lips are not as brilliant in color. Add Flesh around the outside of the mouth to create the skin tones.

Using Prismacolor

For a burnished mouth, I began the same but replaced the graphite with Tuscan Red Prismacolor instead. Keep the layers smooth since layering is not as even with Prismacolor as it is with Verithin.

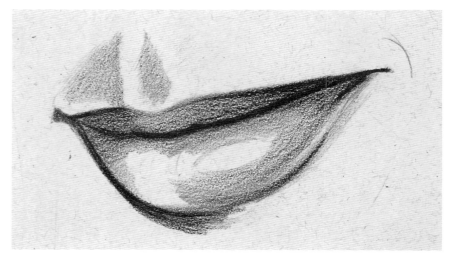

Add Carmine Red Prismacolor over the Tuscan Red. Keep it smooth! Leave the color of the paper for the highlight areas.

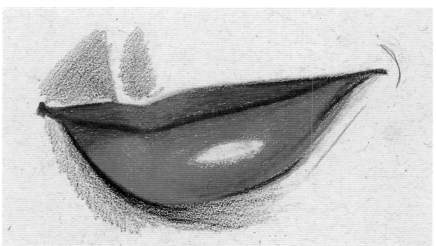

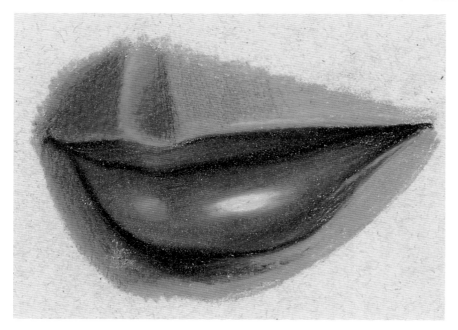

Add peach Prismacolor around the mouth for skin tones. Add white Prismacolor to the highlight areas of the lips. For an even shinier look, I sprayed the final drawing with gloss damar varnish. (The drawing done in Verithin was not sprayed at all.)

Using Col-erase

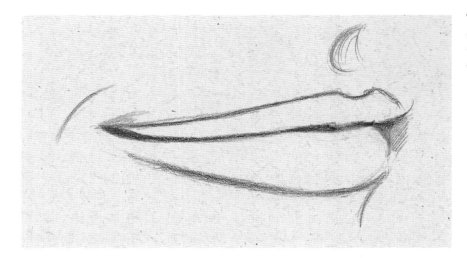

This mouth was done with the Col-erase pencils. Begin the process the same way, replacing the graphite with a Tuscan Red Col-erase pencil.

Add Tuscan Red Col-erase to the upper lip for darkness and some shadows on the lower lip. Add Carmine Red Col-erase to both lips for color, overlapping into the Tuscan Red.

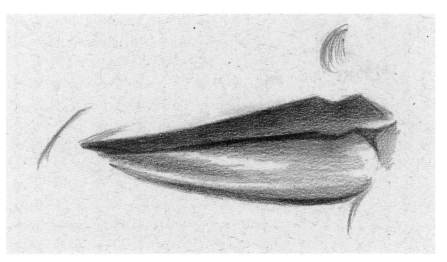

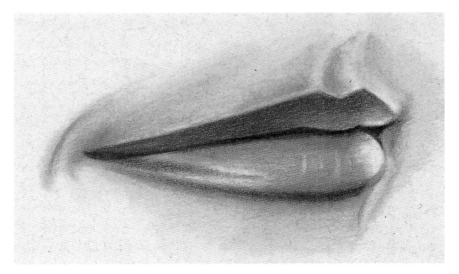

With a clean tortillion, blend out the tones for a soft look. Add Flesh Col-erase for the skin tone and blend again. "Lift" the highlights with the point of a typewriter eraser. To maintain the pastel qualities of this drawing, I did *not* spray it with a fixative.

A Variety of Looks

Practice is so important for developing your skills and understanding. Here are some sample mouths for you to draw from. Use your graphs to get the shapes accurate. I have described for you the technique and pencils I used for each one. Take your time and have fun with these.

When you have completed these for practice, try drawing from some actual photographs or pictures in magazines. Study the colors you see in the photos. Decide which technique would give you the look you want or come closest to replicating the look and colors seen in the photo reference.

Experiment also with different paper colors and see how the pencil colors change whenever you use a darker paper or when the paper is close to the skin color you are drawing. The possibilities are endless.

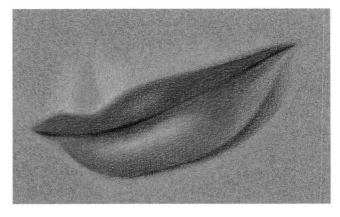

Layered Verithin on Steel Gray Artagain paper. Colors: Tuscan Red, Terra Cotta, Flesh and white

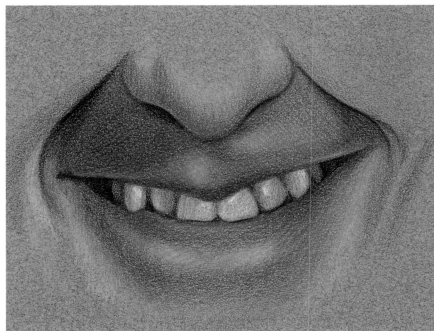

This was done on the same paper and with the same colors as the drawing above. White Verithin was used for the teeth. Because Verithin does not cover completely, the paper color came through to help create the shadows on the teeth. For the bright highlights, I used a white Prismacolor. The corners of the mouth were done with a combination of black and Tuscan Red Verithins.

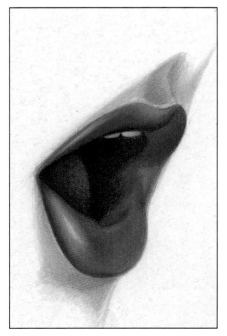

An unusual pose rendered in burnished Prismacolor. I used Chamois Renewal paper.
Colors: black, Tuscan Red, Carmine Red, Scarlet Red, peach and white

This too is on Chamois Renewal paper. I used similar colors, but can you see how the skin tone in this drawing has more of a pink tint than the other? This is important because every person has a different skin tone. Rather than just using the peach Prismacolor, I added Blush Pink to achieve the different tone.

The shadows on the teeth are reflecting surrounding colors. I have used peach, Goldenrod, Light Umber and white.

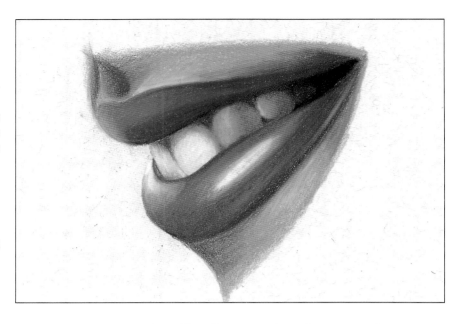

This illustration shows how two techniques can be used together. Here the burnished look is used to create the shiny characteristics of the lips, while the layered look has been used to portray the texture of the skin. This makes the lips stand out even more. I used a yellowish paper (Strathmore Beachsand Artagain) to help create the color of the skin.

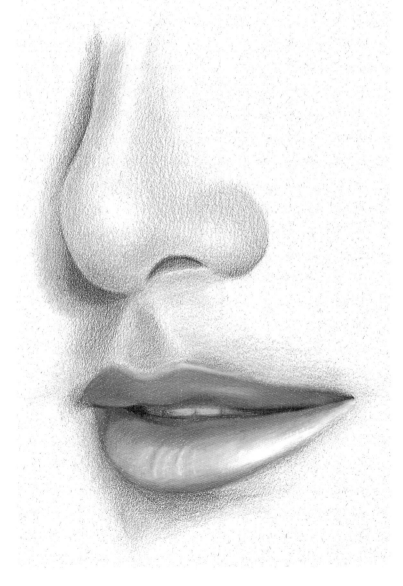

Drawing Men's Lips

Drawing men's lips is very different from drawing women's lips, especially when working with color. Women's mouths are usually more colorful and pronounced because of the use of cosmetics, but are also by nature more shapely. Many times, men's lips are much less noticeable and defined.

Looking at the male mouth on page 44, you can see how the lips themselves appear more as shadow areas instead of an actual lip shape. The bottom lip is not edged at all, but is completely described by the shadows instead.

Facial hair poses another challenge for the artist. For obvious reasons, you must know how to draw the mouth first, before you try to draw a mustache, since the mustache grows on top of the mouth. The technique shown here takes time and practice. It takes a flick of the wrist to avoid lines that look rigid. Practice before you attempt this on an actual drawing!

This drawing was done on flannel white Artagain paper. It was sprayed with workable fixative.

With a tortillion, blend your colors together until smooth. "Lift" the highlight out of the lower lip with your typewriter eraser.

To draw the mustache, take a *very sharp* black Prismacolor pencil and apply very quick, tapered strokes to replicate hairlines. Add more quick strokes using a *very sharp* white Prismacolor. The pencil strokes must be very quick in order for the lines to taper at the ends and not appear too hard and stiff. Overlap the hairlines and vary their lengths until they build up in layers.

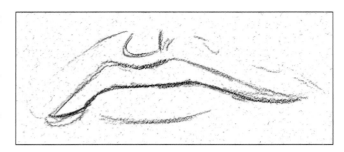

An accurate line drawing in graphite.

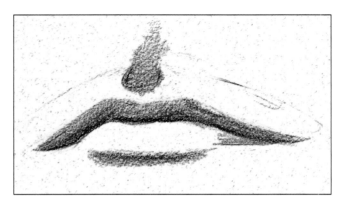

This drawing is done in Col-erase pencils. Slowly replace the graphite lines with a Tuscan Red Col-erase pencil. Darken in the upper lip and the area above and below the lips.

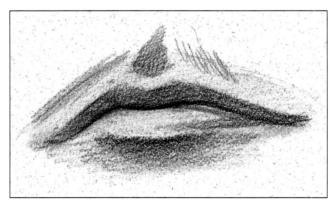

Add more Tuscan Red above the mustache line and below the lower lip. Add Flesh color for the skin and lip tones.

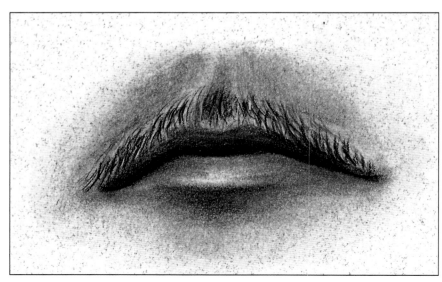

On Darker Paper

Here's an exercise for drawing darker skin tones. I have selected a darker paper color for this project to enhance the bronze undertones of the skin. It is cresent mat board no. 3319, Topaz. The texture of the board is somewhat rough, giving the drawing a masculine appearance.

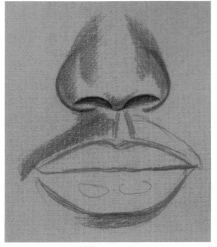

Once you have the accurate line drawing, begin substituting the graphite with a Dark Brown Prismacolor pencil. Fill in the nostril areas and begin the shading to create the shape and form of the nose.

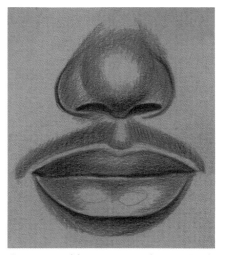

Continue adding tones with your Dark Brown Prismacolor. Place brown into the mustache area as a foundation to build the mustache on later. Never apply facial hair without first putting pigment underneath.

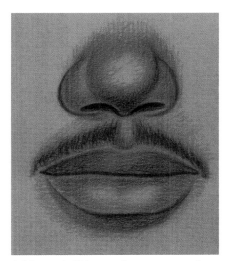

Add peach Prismacolor to create the skin tones. Add black hair lines with a very sharp black Prismacolor. Be sure to use quick strokes.

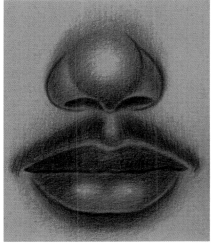

Add Tuscan Red Prismacolor on top of the peach to deepen the skin tones. Add some black under the lower lip for more shadow. Add some black to the upper lip to create more fullness.

This drawing could be considered finished at this stage if you want your work to have the layered look.

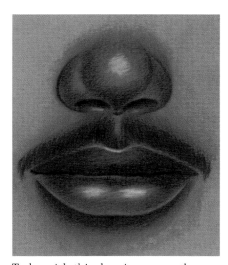

To burnish this drawing, cover the entire surface with a peach Prismacolor. Reapply your darks with the Tuscan Red and Dark Brown, softening them in with the peach. Add white to the highlight of the nose, the edge of the upper lip and the highlights of the lower lip. Since this drawing was done in all stages with the Prismacolors, you must spray it to keep it from blooming and becoming cloudy.

DRAWING THE EAR

Although ears are seldom anyone's most attractive feature, you cannot draw portraits without them (although some of my students have tried). I often hear that ears are hard to draw. Part of it is because they are somewhat complex in their shapes. But I also think they are one of the features about the face we don't really look at, so we don't have a good mental image of them to fall back on when drawing. Believe it or not, this will help you now. Since you will not be able to draw from memory, you will be forced to really look at your reference, seeing it as shapes. This is the key to good drawing.

The following exercises will help you understand the anatomy of the ear and its complex shapes. This knowledge will make drawing ears easier for you.

Because of the irregular surface of the ear and its somewhat shiny appearance, there are many areas of shadow, along with reflected light. Watch for these areas as you draw.

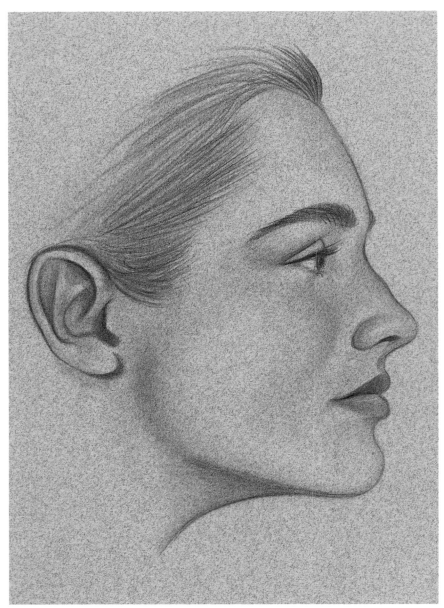

Profile view of the ear. This shows you the placement of the ear, and its relationship to the other facial features.

The top of the ear generally lines up with the eyebrows. The bottom of the ear generally lines up with the bottom of the nose.

Pencils used:	Col-erase
Technique:	Blended
Surface:	Moonstone Artagain paper
Sealant:	Workable fixative
Colors:	Brown

Drawing Ears, Shape-By-Shape

Ears are complex because of their "shapes within shapes" characteristics. Their overlapping surfaces are sometimes hard to follow when drawing, causing you to feel as if you are drawing a maze instead of an ear. The following illustrations show you the ear drawn in three different styles and color schemes.

Look for the soft edges where the ear is softly curved, as well as the hard edges where the surfaces overlap each other. Always remember to soften the tone out from the edge so it does not appear as an outline.

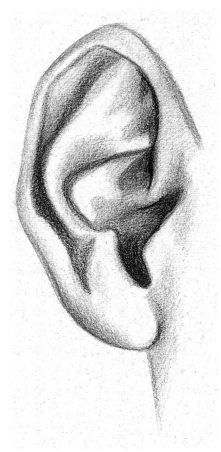

Black Verithin layered on Beachsand Artagain paper.

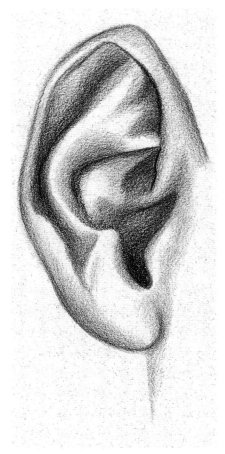

Black and Dark Brown Verithin. A monochromatic color scheme.

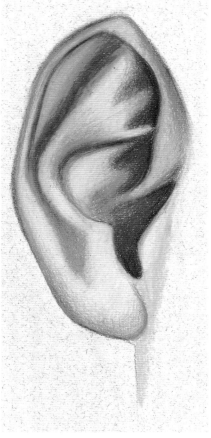

A full color drawing in burnished Prismacolor.
Colors: Dark Brown, Tuscan Red, Terra Cotta, peach, Light Peach, cream and white.

A Practice Ear

This exercise will help you understand and obtain the shapes found in the ear. By using the graph, you will be able to divide the ear, isolating the shapes into more workable patterns. It is important to see the ear as just nonsense shapes, forgetting that you are drawing an ear. Turn the drawing upside down if it will help your mind stop identifying with the subject matter so literally. Whenever we can see our subject simply as random shapes all fitting together as a puzzle, we have simplified the process for drawing it accurately.

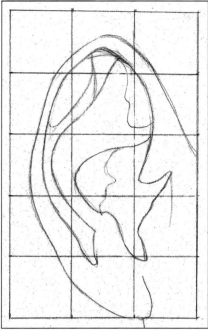

Let the graph divide the shapes of the ear into easier pieces to draw.

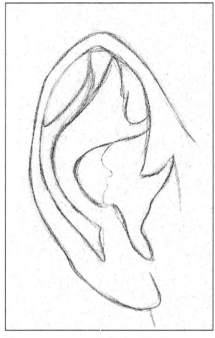

Once you are satisfied with the accuracy of your shapes, remove the graph.

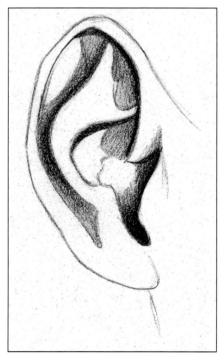

Begin placing the dark areas of the ear with a sharp black Verithin pencil. These dark areas are created where two surfaces of the ear overlap, creating shadows (hard edges).

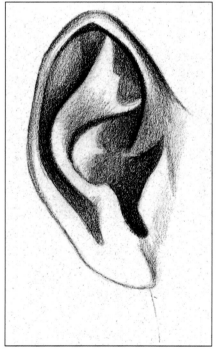

Continue adding tone to create the shape. Notice how the dark areas recede now, while the lighter areas seem to come forward.

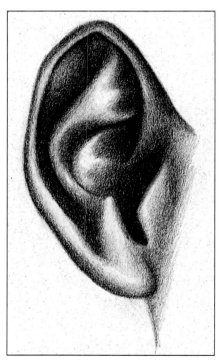

Now the tones are complete and the form of the ear is realistically illustrated.

Ears in Full Color

Try the process once again, using more colorful pencils on the peach-colored paper, shell renewal. Pay particular attention to the shapes again, as well as how the lights and darks of the ear look different when drawn in color.

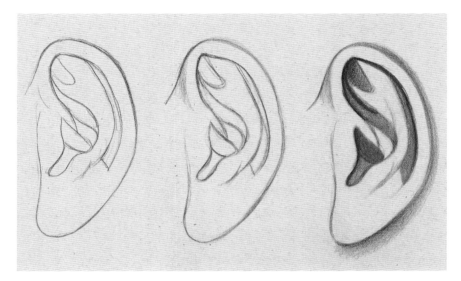

An accurate line drawing.

Begin replacing the graphite with a Dark Brown Verithin pencil.

Draw in your dark shadow areas. Notice how this ear has a dark shadow behind it, making the edge of the ear appear lighter, instead of dark (as in the black-and-white drawing on the previous page). Look closely. Can you see the reflected light around the edge of the earlobe? This wouldn't be as evident without the darkness behind it.

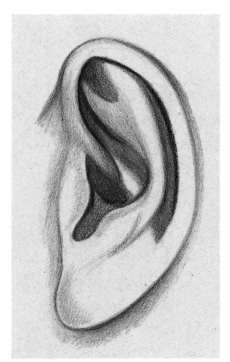

Continue adding brown tones to make the ear take shape. Adding tones will create depth in your illustrations.

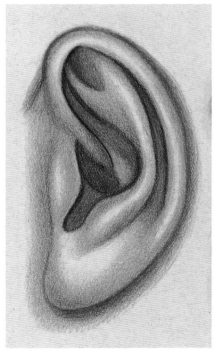

Add Terra Cotta Verithin to the drawing. This color combined with the peach color of the paper creates a very nice skin tone. For a Verithin drawing you could stop here and call your drawing complete.

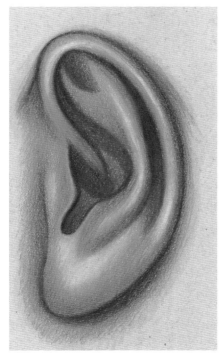

This drawing was burnished with Light Peach Prismacolor. Using the same colors in Prismacolor as you just used, reapply the colors and blend them with Light Peach. White Prismacolor has been added in the highlight areas.

Partial Ears

Seldom do you see the entire ear in a portrait, unless you are drawing a profile view. By looking at the ear in a typical straight-on view, you can see how little of it really shows. It helps to practice drawing the ear in many different poses just as we did with the nose and the mouth. Go through magazines and study both male and female, adult and child to become familiar with the differences.

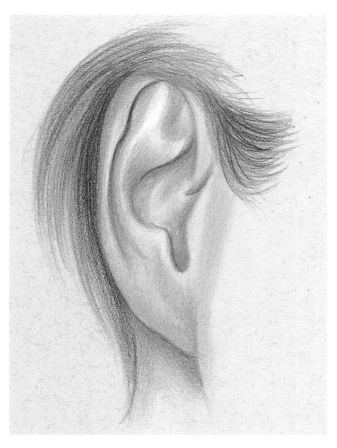

Hair will often hide a portion of the ear. Although drawing hair will be covered later in the book, you should practice drawing the ear along with some hair. It requires the same quick strokes you learned while drawing the mustache.

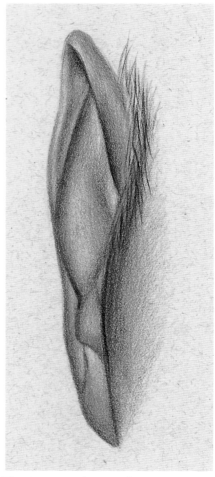

This is a typical view of an ear, as seen from a head-on view. It looks completely different than the side view. Due to perspective, you see a very condensed version with not as many details.

Using a darker paper to enhance the color of the hair, this drawing shows how an ear looks when covered with hair. Although it would be tempting to just fill the hair in so the ear wouldn't show at all, this gives you much more realism. Notice how I have used both dark and light colors in the hair, which makes it look layered. Also, jewelry is fun to draw, so don't leave it out!

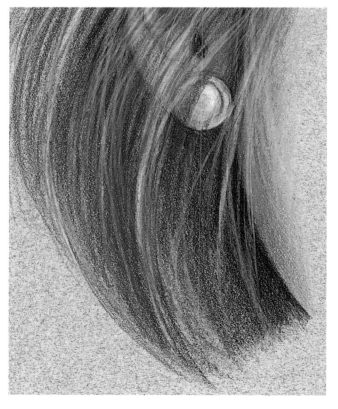

DRAWING THE EYES

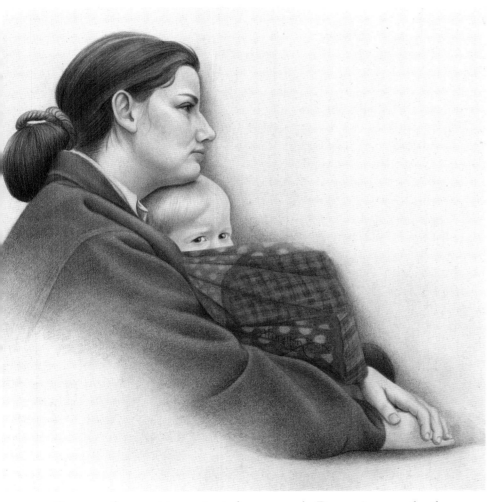

Pencils used:	Verithin enhanced with Col-erase
Technique:	Layered (entire drawing with Verithin) Blended (Gently blended *over* the Verithin for softness)
Surface:	Moss Renewal paper
Fixative:	None (to maintain the soft quality)
Colors used:	Dark Brown, Tuscan Red and Indigo (clothing and hair) Flesh, Tuscan Red and Carmine (skin tones) green (quilt) black (hair, shadow areas) black Prismacolor used for eyes white Prismacolor used for catch lights in the eyes and other highlights.

"Cathi and Kim"
19" × 24" (48cm × 61cm)

Eyes are the most important element of any portrait drawing. They convey the emotion, feeling and the very soul of the individual being drawn. The eyes are a combination of beautiful shapes and colors and become the focal point of your art-

work. Drawn incorrectly, the very things that should be the most inviting aspect of your drawing can ruin the entire essence of your subject.

Eyes are my favorite thing to draw. It does not matter to me if

they are human eyes or animal eyes, I draw them whenever I can. I never tire of their beauty and their ability to pull the viewer into the art. Look at the story that can be told simply by the eyes of the child.

An Eye for Detail

No other subject matter is changed more by the technique you choose to use. Look at how different all of these eyes appear when rendered in a different fashion. Each one of these takes on a whole separate feeling since eyes show emotion. The colors you decide to use in your artwork should help portray the feelings you are trying to convey. The eyes drawn in color have a much warmer, happier look to them than the eyes done in gray tones. It is amazing how much impact color has.

Like the ear, the eye is made up of many interlocking shapes. Accuracy in these shapes is essential, not only in capturing your likeness, but also in making the eyes look toward the right direction. Again, your graph will be indispensable in obtaining your line drawing. Also, you will want to use a circle template to draw the perfect circles required for the pupil and the iris.

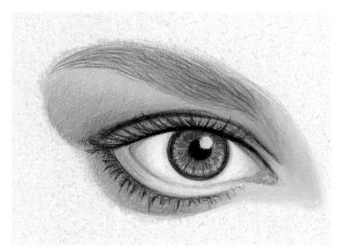

Full color burnished Prismacolor.

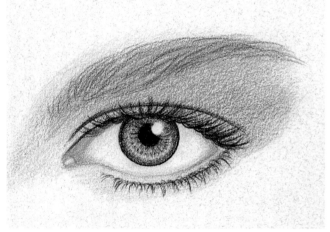

Full color layered Verithin.

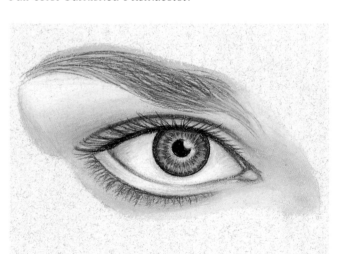

Black-and-white burnished Prismacolor.

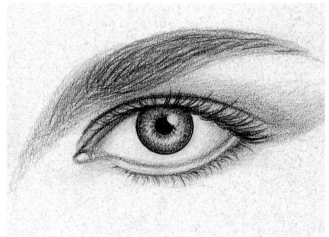

Black layered Verithin. All drawings done on Beachsand Artagain paper.

Brows and Lashes

Before we get into the complexities of the eye itself, let's start with some of the important details, such as the eyebrows, lashes and eye colors. These exercises will help you master potential problem areas first, giving you a head start when you draw the open eye.

This is a lash line. It is usually quite dark and is seen on the upper eyelid. The lower lash line is very light.

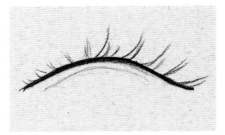

Begin applying lashes using very quick strokes with a sharp black Prismacolor. The strokes should originate at the lash line and taper at the ends. Look at how the lashes curve, as well as the direction they are going. Notice that eyelashes grow in clumps, not individually and all in a row.

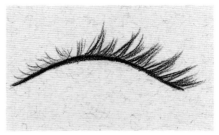

Continue adding lashes in random lengths and thicknesses. Use very light and quick strokes, and build them up gradually.

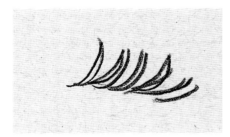

These lines are much too harsh and thick!

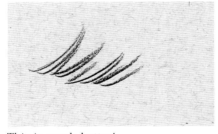

This is much better!

Draw the eyebrow as a shape and fill it in lightly and evenly with a sharp black Verithin pencil. (If this were being drawn in color, you would use brown.)

Slowly add hair lines using very quick strokes with a sharp black Prismacolor. Pay attention to the direction that the hairs are growing.

Continue filling until you get the fullness you want.

Adding some lines to the hair with a white Prismacolor can give the illusion of light reflecting.

Eye Color

Give yourself a light graphite outline. Use a graph for shape.

With a flesh-colored Col-erase pencil, cover the eyelid, eyebrow, as well as the area below the eye. Add Tuscan Red and pink Col-erase to the eyelid, leaving the light area to represent the roundness (or bulge) of the eye. Add brown Col-erase pencil to the eyebrow area.

Blend the tones together with a tortillion. Add black Prismacolor to the crease of the eyelid and along the lash line.

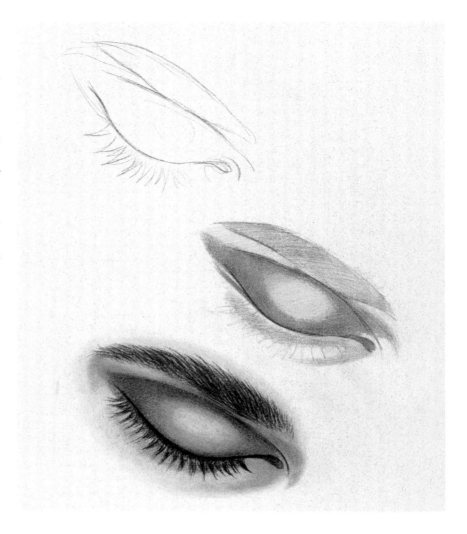

Here's how to draw eye colors. Begin with the iris, pupil and catch light. The catch light is always half in the pupil and half in the iris. It is what makes the eye look shiny and expressive. With black Verithin, add tone around the edge of the iris.

For a blue eye, add Indigo Blue, creating some patterns coming out from the pupil in a starburst design. Add white Prismacolor to the catchlight. This would be finished if done in Verithin only.

To burnish, cover everything with white Prismacolor and reapply your colors to enhance the patterns. A burnished eye looks shinier than a layered one.

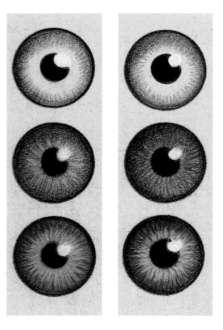

◄ For a green eye, follow the same steps but use Olive Green.

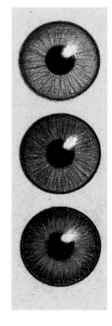

For a brown eye, follow the same steps but use Dark Brown. ▶

Putting It All Together

You are now ready to draw the entire eye. Go slowly and follow the directions closely. Remember, this is a crucial element of portrait drawing. You must be proficient at drawing eyes if you want your portraits to have good character.

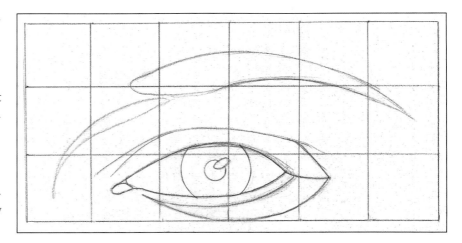

Use the graph to draw your shapes accurately. Use a circle template to draw the irises and the pupils.

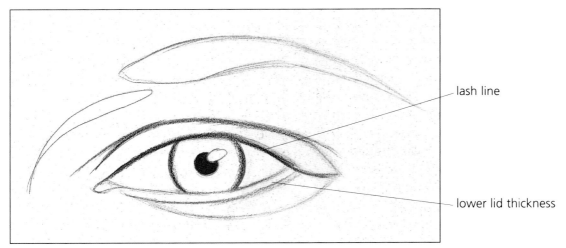

lash line

lower lid thickness

With a black Prismacolor, blacken in the pupil. It is *always* centered in the iris. Notice how the catch light is half in the pupil, and half in the iris. This gives the eye its shine. Darken the lash line and the area around the iris.

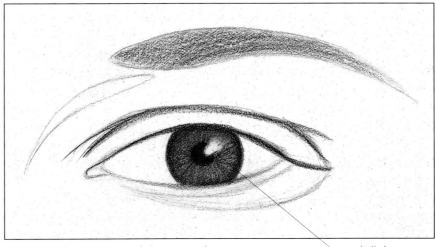

catch light

Fill the eyebrow area and the iris with black Verithin. Using a starburst design, create some patterning in the iris. Do not cover up the catch light.

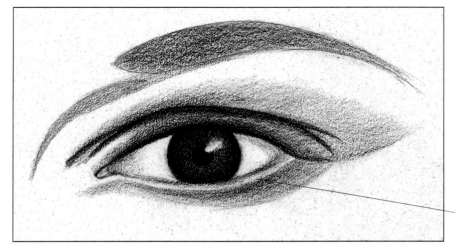

Begin placing tone on the eyelid, on the brow bone and below the eye. Look for the lower lid thickness. This gives the eye dimension and is necessary for realism. Be sure to leave it light since it reflects light. Add some subtle shadows to the eyeball.

lower lid thickness

Apply the eyebrows and eyelashes using quick strokes with a sharp black Prismacolor. Apply white Prismacolor to the catchlight. This would be finished if done in Verithin only.

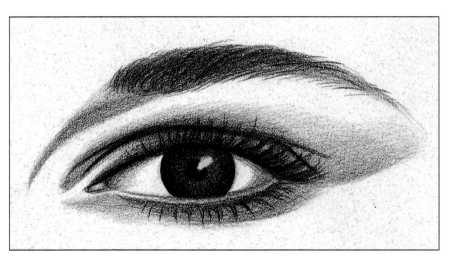

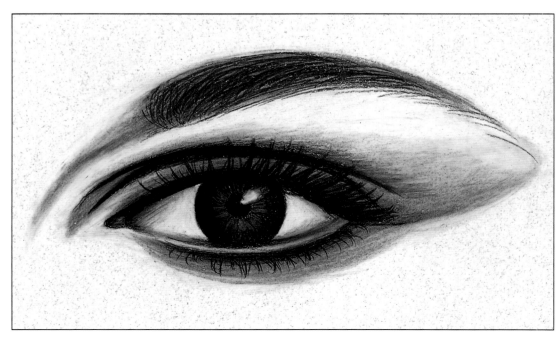

I burnished this drawing with a white Prismacolor. I then reintensified the tones with black, blending them together with the white. I think this technique makes eyes look shinier.

Eyes in Full Color

Female

Let's draw some eyes now using color, exploring the differences between male and female eyes.

I find the most recognizable difference between the two is in the eyebrows. Men usually have thicker eyebrows with less arch to them. Their eyebrows and brow bone are often closer to the eyes. Women, on the other hand, usually have thinner brows with more arch.

Cosmetics will often make a woman's eyes stand out more, with the eyelashes seeming more full and noticeable. But be careful. Every person is different, and there are exceptions to every rule and generality. Study your reference carefully. You must draw the features as they appear for that particular individual.

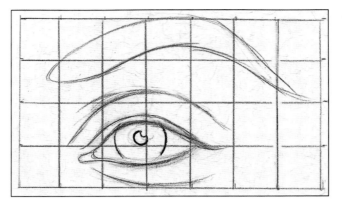

A graphed, accurate line drawing on chamois renewal paper.

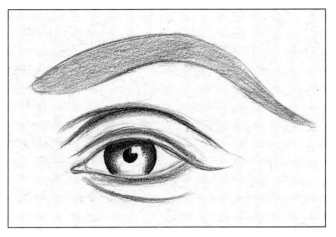

Begin replacing graphite with Dark Brown Verithin. Fill in the eyebrow area with Dark Brown also. With a black Prismacolor, fill in the pupil, but be sure to leave a catch light. (Remember, half in pupil and half in iris.) Darken iris area with black.

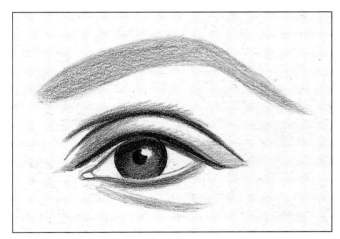

Add more Dark Brown Verithin to the lid area and eye crease above the eye. Apply Dark Brown below the lower lid thickness. Add Dark Brown to the iris.

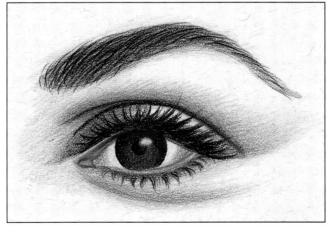

Add Flesh Verithin to the skin tones. Add Tuscan Red to the eye crease, inner eye membrane and along the lower lid thickness, and some to the shadow below the eye. Deepen the eye color with Dark Brown. Add white Prismacolor to the catch light. Finish by adding eyebrows and eyelashes. Notice how the lashes on the lower lid grow off the lower lid thickness. You *must* have a separation between iris and lashes or the eyes will look outlined and unreal.

Male

The man's eye was drawn on Beachsand Artagain paper, which has more of a yellow tone to it than the paper used for the woman's eye. Draw this eye using the same procedure from the previous exercise. Notice how the man's eye has more eyebrows but fewer eyelashes. Be sure to use a graph to obtain the correct shapes. Since this eye is looking in a different direction, it will be very important to place the iris and pupil in the proper place.

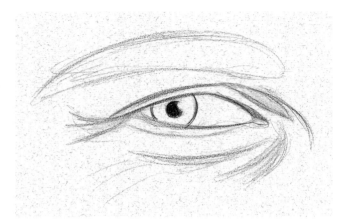

After drawing the line lightly in graphite, the pupil is filled in with black Prismacolor.

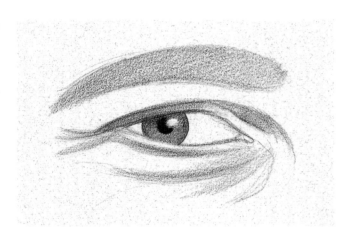

Dark Brown Verithin is added to the iris, shadow areas and eyebrow. Black Verithin is added around outside edge of the iris.

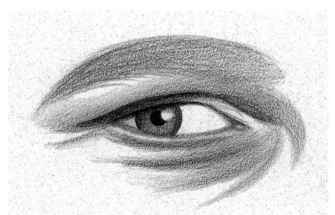

Tuscan Red Verithin is added above the eyelid, helping create the curve of the brow bone. Tuscan Red is also placed in the corner of the eye membrane and into the shadows beside and below the eye.

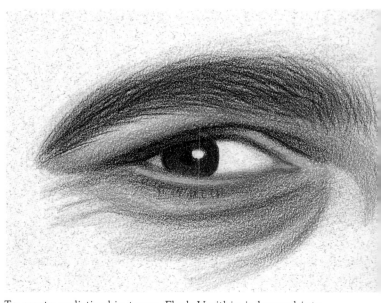

To create realistic skin tones, Flesh Verithin is layered into Tuscan Red. A light touch helps the colors blend and gently fade into the color of the paper. Dark Brown Prismacolor was added to the iris for strength of color. White Prismacolor was added to the catch light for shine.

Looking in a Different Direction

I mentioned how the eye is looking in a different direction in the previous exercise. The face is turned, with the eye still looking toward you. But what happens when the eye looks away from you? We have learned that the iris and pupil of the eye are perfect circles, which is extremely important. But this is only true if the eye is looking directly at you. When the eye looks in a different direction (and away from you), what you see is no longer a perfect circle. What you are seeing is a circle in perspective, or ellipse.

Study this eye. At first glance, the iris does appear to be a perfect circle. But closer observation will show you that it is actually a subtle vertical ellipse. If it *had* been drawn as a perfect circle instead of the ellipse, it would have changed the gaze and direction of the eye, making it appear to straighten out and look toward you.

Whenever you have eyes that are looking away from you, whether it be from side to side or up and down, you will be dealing with ellipses rather than circles. A template is still necessary to achieve the right shape, so purchase templates with both circles and ellipses. Don't be tempted to try to freehand the eyes. Both eyes must be the same shape and size, and if you plan on drawing portraits, it will be well worth the investment of a few dollars!

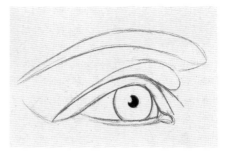

Begin with an accurate line drawing on Shell Renewal or peach-colored paper. Use an ellipse template to draw the pupil and the iris. The pupil is still centered in the iris, even when working with ellipses. Darken the pupil with a black Prismacolor. Do not forget the catch light.

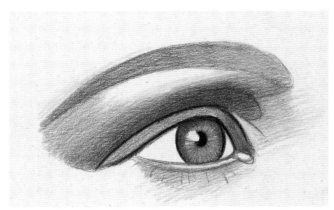

Begin layering colors with your Col-erase pencils. Use Indigo Blue and black for the iris. Use Black for the lash line and eye crease. Apply more Indigo Blue to the eyelid and above the eye crease.

Apply Tuscan Red over the blue above the eye. This will create a Violet shade. Apply more Tuscan Red into the corner of the eye and fill in the eyebrow area. Also, shade the brow into the crease of the eye with Tuscan Red to make it look rounded, and shade below the lower lid thickness.

Apply some Flesh Col-erase pencil as a transitioning color to soften the Tuscan Red into the color of the paper.

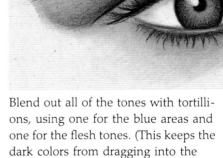

A perfect circle.

Blend out all of the tones with tortillions, using one for the blue areas and one for the flesh tones. (This keeps the dark colors from dragging into the lighter ones.)

Finish the drawing by adding white Prismacolor to the center of the iris for decoration and to the catch light. (See how shiny the eye now looks?)

Add brows and eyelashes with a sharp black Prismacolor.

A vertical ellipse. This is the one used for the drawing above.

Proper Alignment

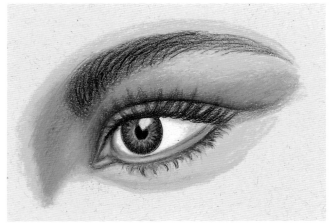

The iris and pupil in this eye are also vertical ellipses.

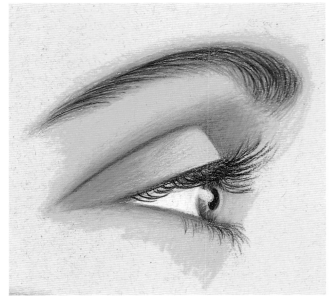

A profile view creates an extreme vertical ellipse.

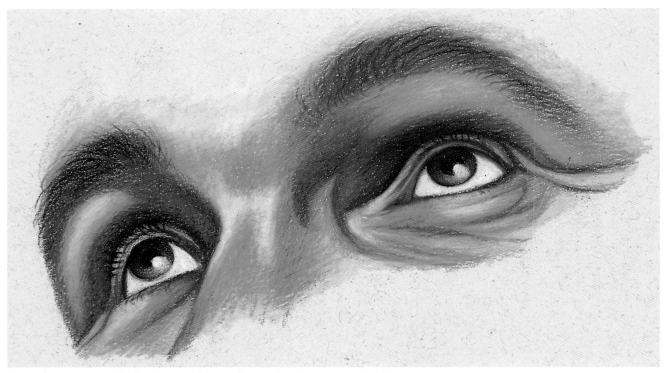

Since these eyes are looking up, and not side to side, they are creating horizontal ellipses. They appear flat, instead of thin.

Accurate Dimensions

When drawing eyes in pairs, there are some guidelines you must follow. Eyes are very symmetrical. When measuring, you will find that the space between the eyes is equal to one eye width. Also, the nose is just below the eyes with it also being one eye's width. By drawing a vertical line down from the corners of the eyes, you will find the edges of the nose. (This is a generality and does not apply to all ethnicities.)

Angles are very important too. A slight tilt of the head will place the eyes at an angle, causing one to be slightly higher than the other one. This is often very subtle and hard to see. It is our nature when drawing to place everything straight across. This will cause the likeness to be off slightly. By drawing a horizontal line underneath the edge of the lowest eye (as seen in the two examples), and then drawing a line under the other eye, you can see just how much higher the one eye actually is.

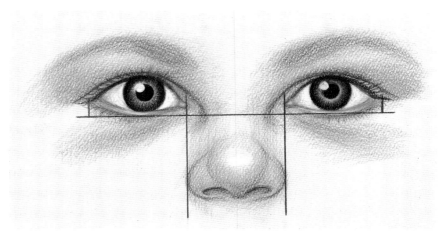

There is one eye's width between the eyes. The nose is also one eye's width— a general rule that does not apply to everyone.

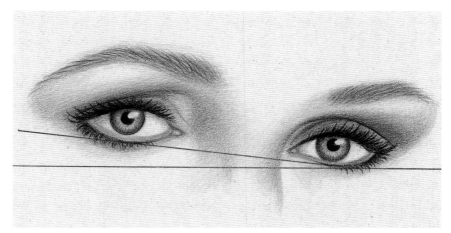

Horizontal lines under the eyes will help you see the tilt of the face. (Layered Verithin drawing.)

Always watch for angles when drawing. Graphing helps keep things in place. (Burnished Prismacolor drawing.)

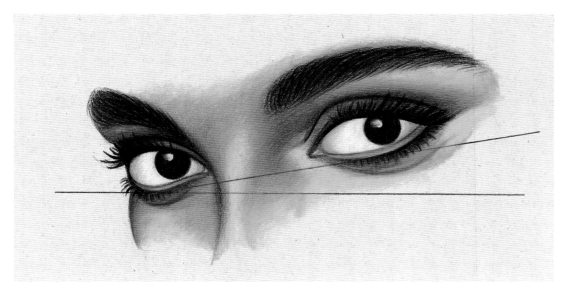

Intense Colors

As I said before, I love drawing eyes. To make these eyes really stand out, I chose to draw them on black-and-gray paper. Experiment with dark blue, brown or green paper. Look at how the white areas in these examples stand out against the toned background. By burnishing the colors, it takes on a painted appearance. Because of the enlarged size, I was able to add many details and colors into the eye that would not ordinarily be seen if drawn smaller. These types of enlarged drawings are wonderful practice and a lot of fun.

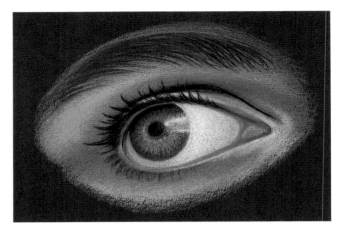

Black paper can make your colors appear very intense, especially when you use the burnished technique.

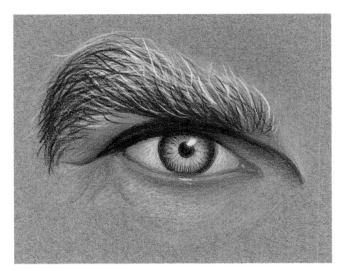

The eyebrow of this eye has been created with a very sharp black-and-white Prismacolor. The white hair lines have been layered over the dark ones.

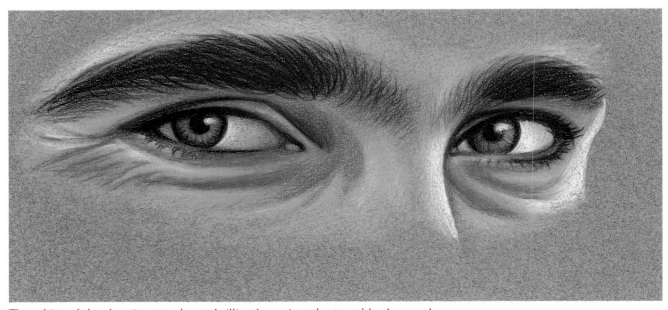

The white of the drawing stands out brilliantly against the toned background.

Drawing Glasses

So many people wear eyeglasses, but it is surprising to find out how many artists avoid having to draw them. Eventually, you will have to draw them, like it or not. The best solution is just to practice. When I was learning to draw, I found that the harder something was, the more I had to draw it. It is the only way to overcome the weakness.

Go through magazines and photographs and look for pictures with eyeglasses. Study the different frames, looking for the colors and shapes. Look and see how they fit on the face as well as the shadows created by them. See how the frames reflect light in areas, with the lens causing both glare and shadows. They are complex and take a lot of thought.

These glasses are both very dark and very light. Look for where it changes from dark to light around the edges. A beginner will be tempted to make them dark and outline all the way around. You must study the effects of light to draw realistically.

To achieve this skin tone, I used darker colors of Prismacolor, Tuscan Red, peach, Terra Cotta, Henna, Burnt Ochre, and Dark Brown and black. It is burnished to make the skin look very smooth.

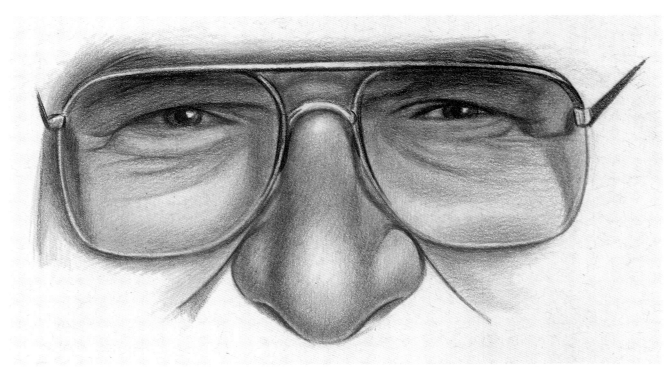

These glasses are very light. Be sure to always check the shapes of the lenses to be sure you are drawing them equal in size and shape. To get the skin tones of this drawing, I layered Verithin in Flesh, Tuscan Red and Dark Brown. Both of these drawings are done on Chamois Renewal paper.

DRAWING THE HAIR

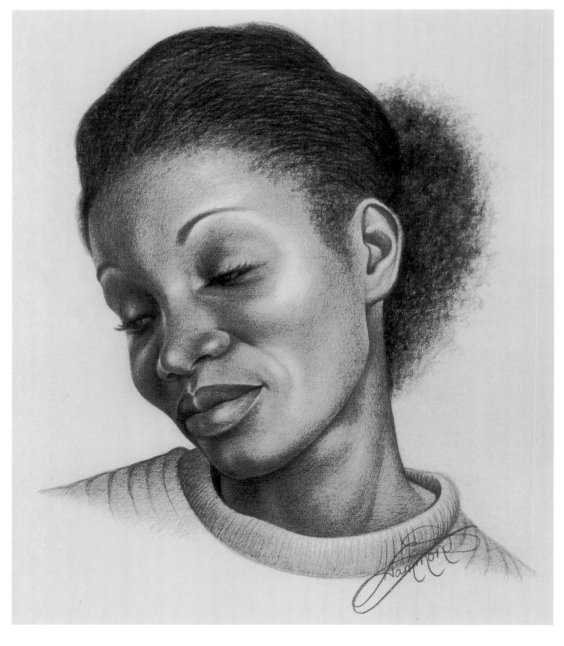

The hair in this example is created using two different techniques. To achieve the fuzzy appearance around the hairline and the temple area, and the soft fluffy look of the hair that is pulled back, I used the side of my pencil rather than the point. Using small, circular strokes, I imitated the direction of the hairs' growth. The hair on the top of the head has more direction to it, so I let the pencil lines show through. This not only gives it shape, but also adds to the fullness.

Untitled
Black and Dark Brown Verithin on 912 India mat board.
12" × 16"
(30cm × 41cm)

Drawing the Hair

Since you now feel confident in your abilities to draw the face, you are ready to add the final touch—the hair. A few minutes and the whole drawing will be done, right? Well, half right, maybe. Yes, the hair should be done last, after the face is completely finished, but it will *not* be finished in a few minutes. Depending on the type of hairstyle you are drawing, more time will be spent on it than on the entire drawing up to that point.

Hair Is Layered

Hair is not a solid mass, so unlike the face, we are not creating the details of just the outer surface. Hair is made up of layers and layers of hair strands, each of them unique in color, texture and direction. While it is not necessary to draw every hair strand, you must draw the hair so that it appears full and layered, not thick and solid.

After doing the step-by-step exercises in this chapter and looking carefully at all the drawings in the book, study the hair more closely and see how the hair was drawn. Look at the build up of colors and the direction of the pencil lines, as well as how they always go with the direction of the hair.

Go through the book and look at how important the hair is to each and every drawing shown. Look closely and see how the colors change with the surroundings and how every person has their own unique hairstyle. Pay attention to how the color of the paper has affected the color of the hair. Everything is interrelated, especially when it is in color.

Light on Top

The most important aspect of the hair is once again the light. The light reflects off the outside layers of the hair. It is very important to make the light in your drawing look as if it is on the top surface. This means it must be added last, on top of the drawing. Many of my beginning students will try to leave out the light, allowing the color of the paper to act as the highlight. This works when drawing the face since the tones are all on one surface, gradually fading into the light. But hair is not a smooth surface. It is built up in layers. If the light is left out, it looks as if your drawing has a hole in it, allowing the background color to be seen. The light will look as if it is coming from behind, rather than being on top. So, remember to add the light colors last and at the top.

Scratching Highlights

I will often scratch more highlights into my work, with the point of a craft knife. Once all of the hair colors have been built up, scratching can help soften the tones into one another and give the illusion of hair strands. Go back and look at some of the illustrations in the book and see if you can tell where I have used this technique. I use it the most with hair that is very thick and completed mostly with Prismacolor. (See Elvis on page 24.)

The following pages will take you step-by-step through some simple hairstyles. These will teach you the basics and get you started on thinking through the process of drawing hair. Be sure to devote the proper time to it. Because of the multiple layers required, hair does take some time to draw right. But it is worth the effort when you see how much it adds to the artwork.

Hair Colors

Remember, these are just basic colors. All of these would be different according to their surroundings and the colors being reflected. Also, this medium-toned paper has enhanced the white tones. These would look different drawn on a lighter paper stock.

Although all of these examples were drawn with Prismacolor, Verithin could also be used for a lighter look.

band of light

The band of light is the light reflecting off of the hair where it protrudes the most. It represents roundness.

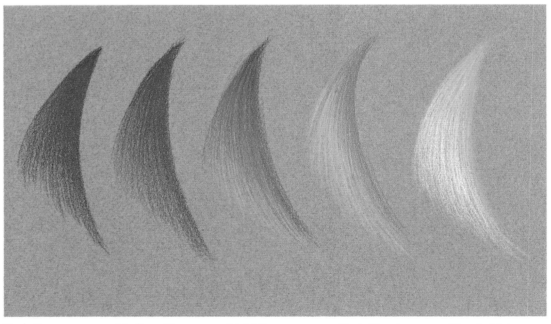

Dark Brown Hair . . . black, Burnt Umber, and Dark Brown

Medium Brown Hair . . . Burnt Umber, Dark Brown and Terra Cotta

Light Brown Hair . . . Dark Brown, Terra Cotta, Goldenrod and cream

Dark Blonde Hair . . . Terra Cotta, Goldenrod, cream and white

Blonde Hair . . . Goldenrod, cream and white

Short, Dark Hair on Gray

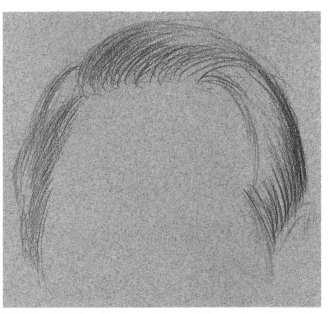

Whenever you can, let the color of the paper help with the color of the hair. I used Steel Gray Artagain paper.

Begin with a simple line drawing of the basic shape of the hairstyle. This drawing was done with Prismacolors.

With Dark Umber, begin applying quick pencil strokes going with the direction of the hair's growth.

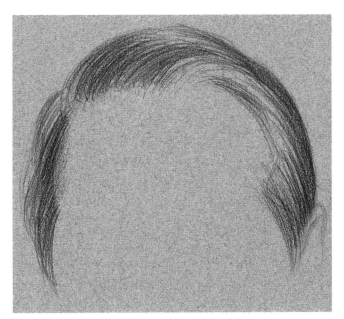

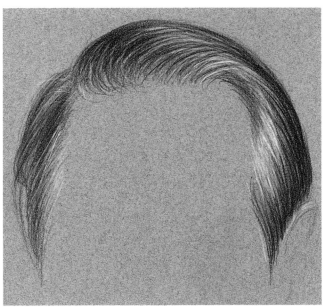

With black, continue to add more pencil strokes to fill in. Be sure to keep a sharp point on your pencil at all times. Use a quick stroke to make the pencil lines taper at the ends.

With white, begin to add your highlights. Compare this drawing to the one in the previous step. Can you see how the white now appears to be on the top surface of the hair? It also makes the hair look fuller.

Experiment with this hairstyle by adding different colors. What would it look like if Light Brown or Terra Cotta was added?

Long Hair, Red or Brown

Draw the overall outline of the shape of the hairstyle. This drawing was done with Prismacolors on Moonstone Artagain paper.

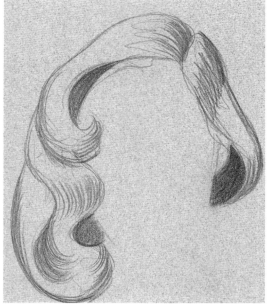

Always start with the dark areas. With Dark Umber, fill in the shadow areas. Begin drawing hair strokes in the dark areas being certain to go in the direction of the hair's growth.

The band of light will be seen on every curl and wherever the hair is rounded and protruding.

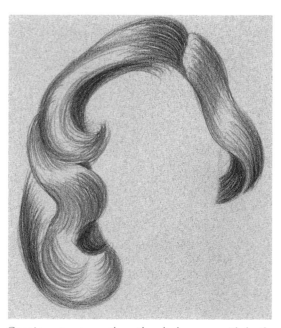

Continue to strengthen the dark areas with both black and Dark Umber. Build up the layers until it looks full and dimensional. For brown hair, you could add the highlights now.

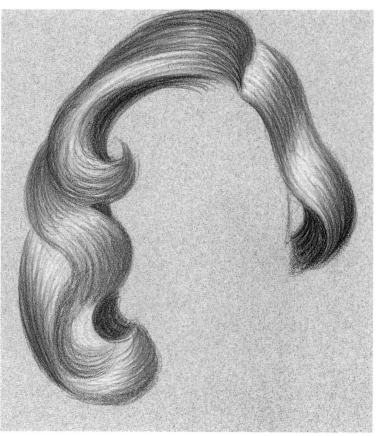

To create the reddish hair color, add some Terra Cotta to the brown areas. White is then applied to the light areas for highlights.

Gray Hair on Blue

Draw the overall shape of the hairstyle. I chose to use Storm Blue Artagain paper.

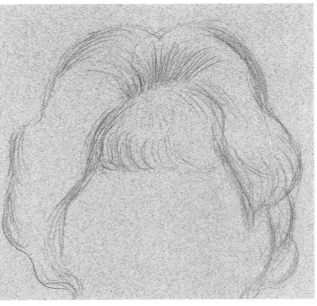

With a light application of black, begin the dark areas going with the direction of the hair. This drawing was done with Prismacolors.

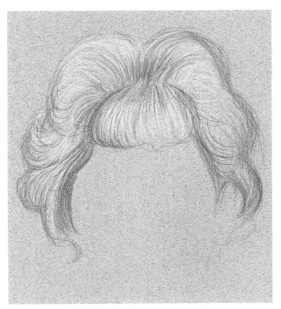

Continue to fill in the dark areas with black. Add white into the light areas to start building the hair layers. Notice how the white seems to come forward against the blue-toned paper.

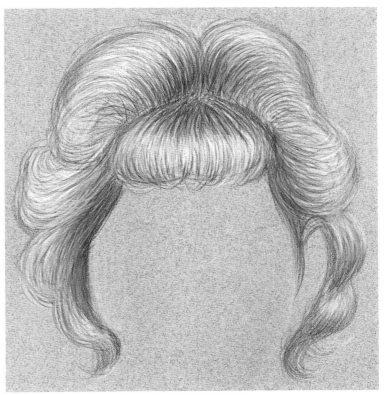

Add some Dark Grey to the dark areas for more contrast. (I used Cool Grey 70 percent). Layer more white into it. Repeat back and forth until you have achieved the look you want.

Using Col-erase Pencils

When using the Col-erase pencils to draw hair, you can use a different approach and technique. This soft hairstyle was started much like the previous exercises. The dark areas were applied first, always going with the direction of the hair. (Look closely and you should see the brown pencil lines.)

Terra cotta was added to the brown to create the hair color, but then I blended the whole thing out with a tortillion to make the hair appear soft. This type of "fluffy" hair does not have as much definition in the hair strands as the longer, straighter styles. By being able to "blend it out," it takes on a softer look.

Highlight areas were lifted with the typewriter eraser instead of being drawn in with the white. Look at the enlarged area of the drawing and you can see where the eraser has lifted the tone going over the dark areas. This makes the light stay on the outside where it belongs.

Darks were added and blended and lights were lifted until these colors took on the soft fullness of the hairstyle.

As I said before, the hair can take a long time. Please give it as much time as it needs. Again, practice will be essential, especially if you want to know how to draw all the hairstyles out there. Go through your magazine pictures and practice all the various styles and colors. Just remember to always look at the hair direction and always begin with the dark areas first. Be sure that the light is on the outer surface. Good luck!

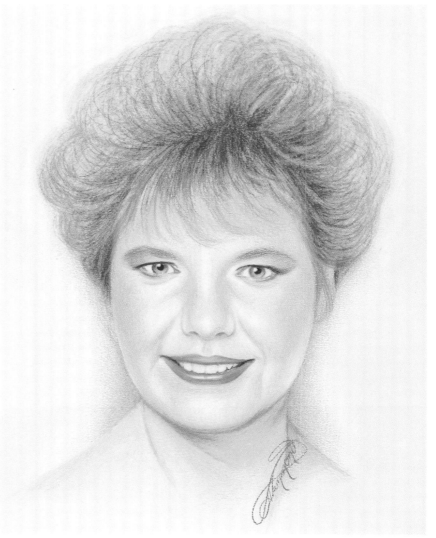

Colors used: brown, Tuscan Red, Carmine and Flesh (skin tones) brown, Terra Cotta and Flesh (hair) Light Blue Col-erase and Sea Green Verithin (background shading)

"Lou"
Col-erase pencils on no. 1008, Ivory mat board.
11" × 14" (28cm × 36cm)

DRAWING THE FACE IN MONOTONES

You now are ready to attempt the entire face, and just like we did with the individual features, we will start slowly. Before rendering the face in color, let's start in gray tones and then work up to a single color scheme, or monotone drawing.

A good photo reference is imperative for this phase. Your artwork will only be as good as the picture you are drawing from. A picture that is too small will force you to guess at what you cannot clearly see. This leads to inaccuracy and a missed likeness.

If you must work from a small picture, have the photo enlarged so you can fully see all of the details clearly. If enlarging the photo gives you a fuzzier impression, resist the urge to use it as artwork.

It helps to begin with a monochromatic scheme so you can concentrate on shapes and tones, without the problem of color. A drawing in gray tones can be just as striking and beautiful as one drawn in color.

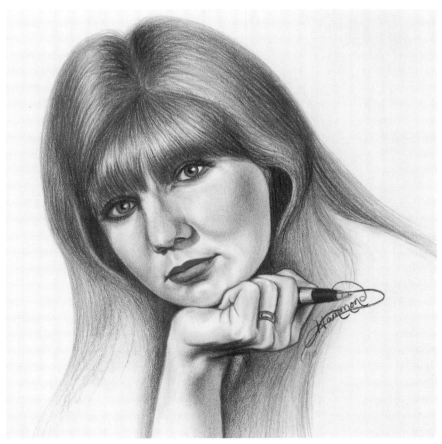

Self-portrait of the author
Black Verithin and Prismacolor on no. 995, Lilac mat board.
16" × 20" (41cm × 51cm)

The pencil in the drawing has been tinted with Scarlet Red Prismacolor.

The eyes in the drawing have been tinted with Olive Green Prismacolor.

The lips in the drawing have been tinted with Carmine Red Prismacolor.

Use a Black-and-White Photo

When working in black-and-white or monotones, it's easier to work from a black-and-white photograph. If the picture you want to do is in color, you may want to have a black-and-white copy made. This will help you see the tones as lights and darks. It is easy to confuse color with shadows when drawing.

I usually have two black-and-white copies made. One will be used to draw a graph on and the other will be to look at and study. By always having one in a graph, you can keep comparing your shapes and placement even after the graph on your drawing paper has been removed. By having one out of the graph, you can see the details more clearly since the graph lines sometimes hide details.

This is the original color photo.

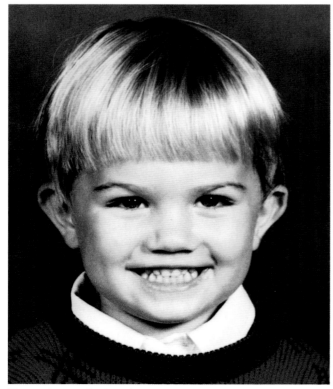

This is how it looks when converted to black and white.

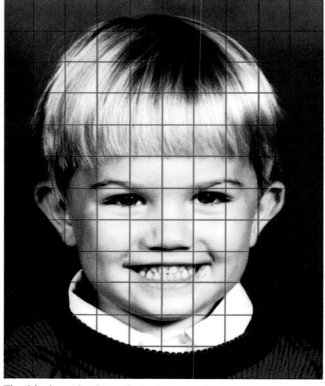

The black-and-white photo in a graph.

Full Face, Step-By-Step

Begin the drawing on any white, off-white, or lightly colored paper. This was done on flannel white Artagain paper by Strathmore. Have both a black Verithin and black Prismacolor ready to go with very sharp points on them. Have all of your tools ready to go, including your kneadable and typewriter eraser, as well as your pencil sharpener!

Follow the directions slowly and carefully. You are now on the way to becoming a great colored-pencil portrait artist!

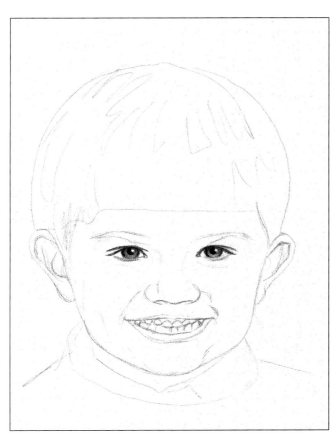

Draw an accurate line drawing of the face using your graph. Pay particular attention to the details of the features, especially the size and shape of the teeth. Do not remove the graph lines from your drawing paper until you are positively sure you have everything as accurate as you are able. When you are satisfied, gently remove the graph lines from your drawing paper with the kneaded eraser.

Always begin any portrait with the eyes. Be sure to use a template for the pupils and irises. The black Verithin will be used for all shading and gentle blends, but the black Prismacolor will always be used for the darkness of the pupils and the lash lines.

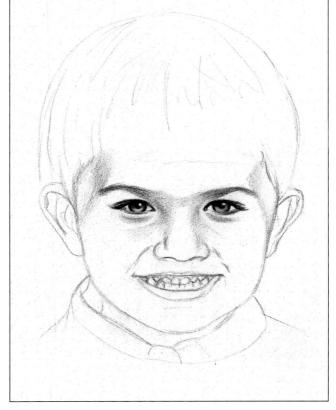

Continue with the shading of the eyes by working up into the brows and along the temple regions. Also include the light shading below the eyes. Be sure to keep a very sharp point on your pencil so the shading doesn't get harsh.

Work your way down the bridge and complete the entire nose. Once satisfied with your results, move down to the mouth area. Study the size and shape of each tooth. Look at the shapes created by the gum line and the dark areas below each tooth. The eyes, nose and mouth make up the "triangle of features," which should be rendered completely before shading the face. Do *not* go any further until you are satisfied with the way the features have turned out.

When you are ready to begin shading, start with the darks along the outside of the face. Work your way in and keep your pencil sharp!

To draw the hair, begin by shading under the bangs. It is important to have the skin tone and a little shadow underneath the hair.

With a very sharp pencil, apply quick strokes into the dark areas. Always go from dark to light. Go from the top of the head downward to where the light area is. Then, go *up* from the bangs, into the band of light area.

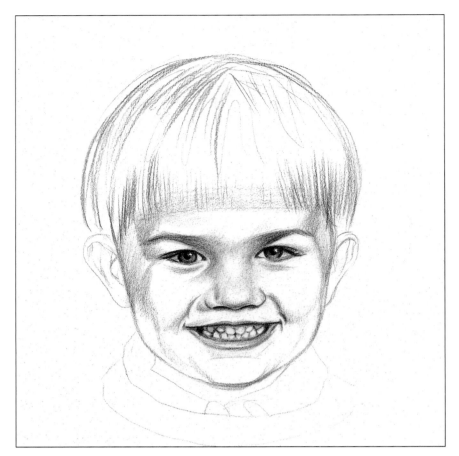

Complete the drawing by finishing the tones and shading on the face and neck. Look for the cast shadow seen on the neck. Look for the reflected light around the edges of the nostrils and along the chin and jawline. These small things are the very details necessary for realism in your work.

Render the ears and then finish the hair. Continue adding quick pencil strokes following the direction of the hair itself. Be sure not to get too dark, and leave the light highlights showing. Bring some of the hair into and on the ears.

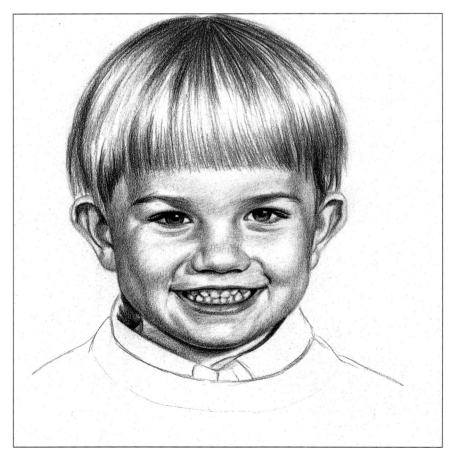

A Three-Quarter View

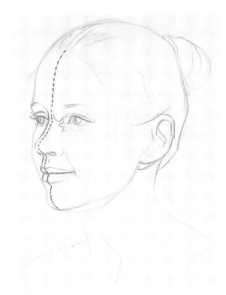

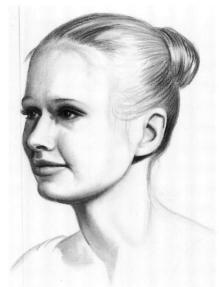

Use a graph to obtain this line drawing. Be careful with the shapes. The three-quarter view changes the way you see the features. The left side of the drawing is far less visible than the right side. Notice the dotted line I drew for you to help you see the circumference of the face. This shows you where the middle of each feature is. Clearly you can see more of the feature on the side closer to you.

Remember, when the eyes are not looking at you, you will be dealing with ellipses instead of circles. Use a template to keep them the right shape and the same size in each eye.

Imitate the shading shown on the face. Complete the "triangle of features" with a sharp black Col-erase pencil. Always work from dark to light gradually. Always start light and build the dark areas slowly, until they are as dark as you want them.

Look for all of the areas of reflected light and the shadow edges, remembering the sphere and the five elements of shading as you go.

Once the dark areas are built up, you can blend with your tortillion. You should notice that the Col-erase pencils do not get as dark as you need them to be, so after you have blended out the tones you will want to intensify the dark areas with a black Prismacolor. These areas are in the eyes, the nostril, between the lips, under the ear and in the shadow areas on the left side of the face.

To change the entire look of the drawing, you can add another color. This drawing has had a layer of Indigo Blue added to it and then blended out. When tinting a drawing like this, it helps to spray down the black-and-white drawing first with workable fixative. Once it is completely dry, you can apply the Indigo Col-erase and blend it out, without the black pencil blending into it. This gives the drawing an interesting look. More of this type of technique will be covered in the chapter on mixed media.

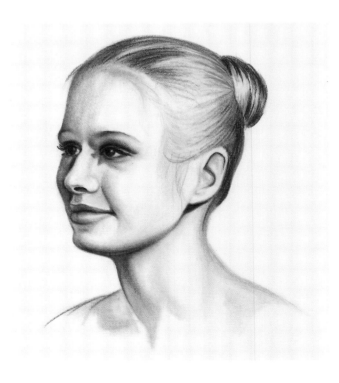

Black-and-White Effects

These examples show how effectively you can use just black or a combination of black and white in your artwork. You can also use different paper colors to enhance the work or add single colors to create unique monotone pieces.

Although this piece would have been adorable in full color, I like the artistic quality it takes on in black and white. I was attracted to the subject matter, but also to the contrast between the soft smoothness of the skin and clothing, as well as the obvious texture of the chair.

They say that a truly great artist will not draw the subject, but will draw the light and its effects *on* the subject. This is important to remember when selecting your subject matter or taking reference photographs. The cutest of subjects can be boring and plain without a good light source to give it life.

Study the technique used for this drawing. Look for the direction of the pencil lines in the texture of the chair and the lack of pencil lines in the skin and clothing. Both of these effects can only be achieved with a very sharp point on your pencil. I cannot stress this point enough!

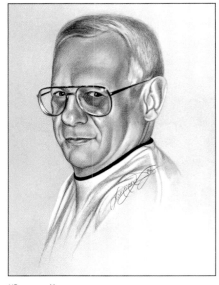

"Lanny"
Gray no. 916, Autumn Mist mat board.
16" × 20" (41cm × 51cm)

Black-and-white Prismacolor (clothing, glasses and eyes).

Black-and-white Verithin (skin tones and hair).

By using a gray mat board, the white of his shirt and the highlights of his glasses and hair really stand out.

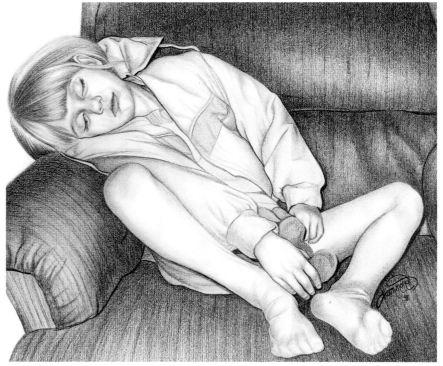

"Annie in Daddy's Chair"
Black Verithin and Prismacolor on no. 903, Soft Green mat board.
16" × 20" (41cm × 51cm)

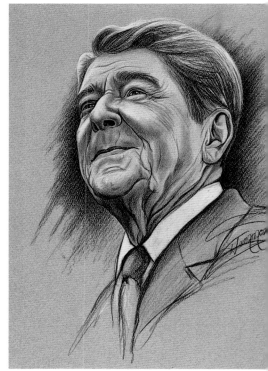

"President Reagan"
Gray no. 1044, Oxford Gray mat board.
16" × 20" (41cm × 51cm)

BLACK-AND-WHITE PRISMACOLOR ▶
This is done on a darker gray mat board than the one before. It also has more texture which gives the piece a much more rugged look.

Brown Tones

A monotone drawing need not be left in just black and white. By adding a little color, either with the pencils you are using or with the paper you are drawing on, the look can be unique and attractive.

These two examples show you how brown tones can be used, giving the artwork the look of the old-fashioned sepia-toned photographs.

The first example is a combination of black and dark brown. The brown tones are very subtle. Although they are hardly noticeable, they act as a softening tool to transition the black tones into the ivory color of the mat board.

The second example is also done in black and brown, but the brown is the main color in this one. The blend that has been created with the Col-erase pencils and a tortillion gives the skin a wonderful, smooth appearance.

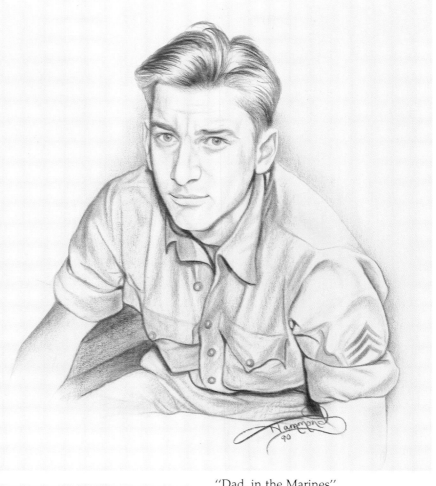

"Dad, in the Marines"
Black and Dark Brown Verithin on no.
3293, Antique White mat board.
12" × 16" (30cm × 41cm)

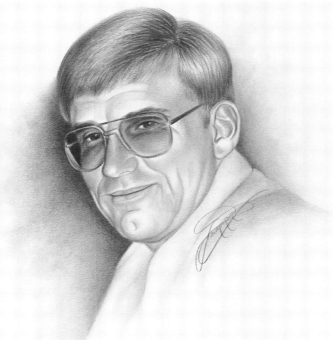

"Bill Hagen, Jr."
Black and brown Col-erase blended on no.
1008, Ivory mat board.
12" × 16" (30cm × 41cm)

Blue Tones

Blue tones can also be used for a unique, creative monotone look. The softness of the first piece was captured by using the Col-erase pencils on a smooth, toned drawing surface. The skin tones were created with black, Indigo and white Col-erase pencils. Black, Indigo and white Prismacolor were used to achieve the dark tones of the hair, while white Prismacolor was used to capture the white of the dress, veil and earring. The result is a very soft, delicate drawing.

While blue tones can appear very soft and pale, they can also take on a very direct look. In the second drawing, the intense values of light and dark are captured by combining the Col-erase pencils with both Prismacolor and Verithin throughout the drawing. Study this example carefully, and see if you can identify where each type of pencil was used.

By fading out the outside edges of the drawing, the eye of the viewer is led to the center, or focal point of the drawing. How to use composition effectively in your work will be explained further in chapter 13.

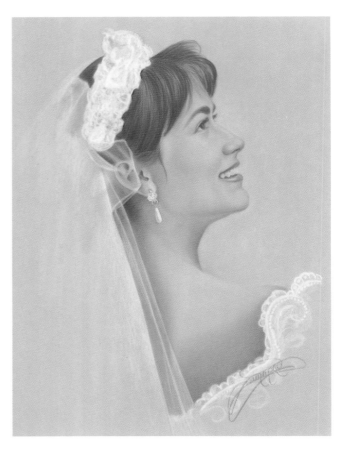

"Kirsten"
Black, Indigo and white Col-erase and Prismacolor on no. 1043, Autumn Gray mat board. 12" × 16" (30cm × 41cm)

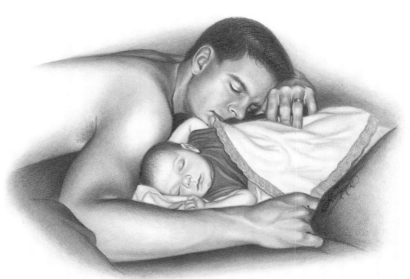

"Geoff and Erin"
No. 1008, Ivory mat board. 12" × 16" (30cm × 41cm)

Colors Used: black and Indigo Col-erase (skin and clothing). Black and Indigo Verithin (background and skin texture). Black Prismacolor (hair and shadow areas).

LAYERED COLOR IN VERITHIN

Once the monochromatic way of drawing is familiar to you, the next logical step is to move on to full color. By now, the feel of the medium should be setting in for you, making you feel more comfortable when drawing. You should feel in control of the pencils, knowing now which pencils to choose to produce and create the specific look or style you want to achieve.

This chapter will take you through the full-color process, giving you a system to follow. You will see the same colors being used again and again, especially in the skin colors. Even though skin tones differ from person to person, the basic colors are the same. Soon it will become second nature for you to see and select the colors that you will need.

Colors Used: Dark Brown, Terra Cotta, Tuscan Red, Flesh, Olive Green (skin tones)
black, Dark Brown, Terra Cotta (hair)
True Blue, gray (clothing)
black, green, Olive Green (background)
black Prismacolor and Olive Green Verithin (eyes)

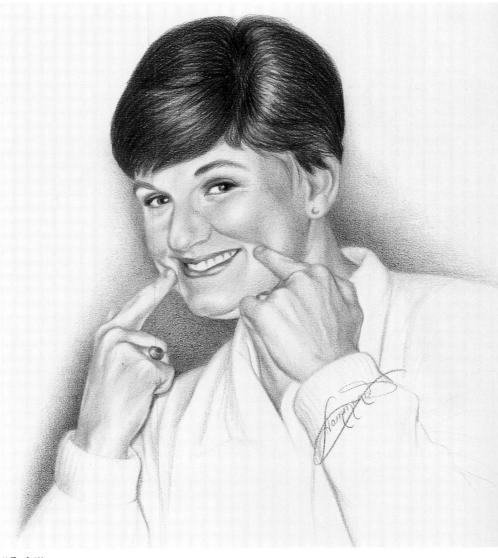

"Cathi"
Layered Verithin on no. 1008, Ivory mat board.
12″ × 16″ (30cm × 41cm)

Full Color, Step-By-Step

Once again, the quality and size of your photo reference is extremely important. You must be able to see the colors clearly in order to replicate them.

By placing the photo in a graph, you will be able to obtain an accurate line drawing. This will look just like the line drawing that we did for the black-and-white study, but this time I have used a tinted paper, chamois renewal paper. When using Verithin and the layered technique, it is important to remember that the paper you select will help create the color of the drawing. For instance, when using full color, I will typically use a warm-toned paper to enhance the skin tones, as opposed to using white or gray paper.

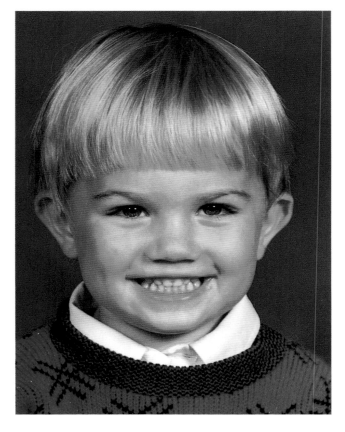

Reference photo.

Accurate line drawing completed with a graph on toned paper.

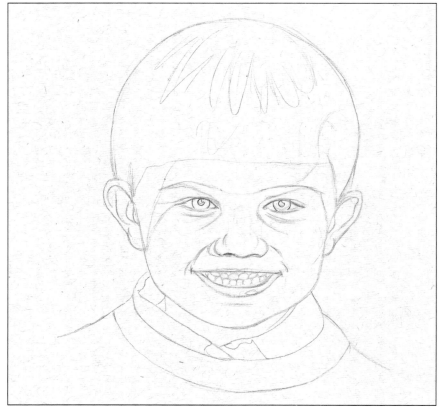

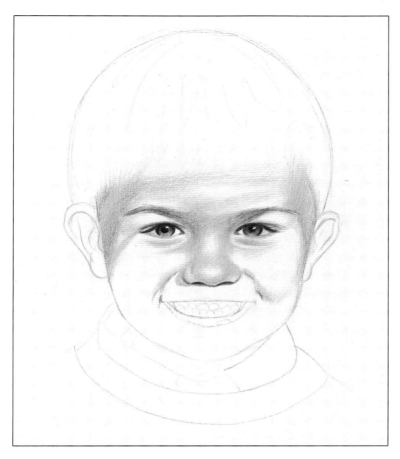

Always begin with the eyes, making sure to use a template for the circles. These eyes were rendered with black Prismacolor and Indigo Blue Verithin.

Use a Tuscan Red Verithin for the shadow areas between the eyes and the temple area. For the eyebrows, apply a layer of Tuscan Red and add Dark Brown for detail. Transition (or soften) the Tuscan Red areas with a Flesh Verithin, and also add Flesh into the forehead area. Keep a sharp point on your pencils at all times!

When the eyes are done, work your way down to the nose. It is rendered with Tuscan Red, Terra Cotta and Flesh.

When the nose is complete, move down to the mouth (the triangle of features). Refer to the black-and-white version of this drawing to refresh you on the process of drawing the teeth.

The lips and gum line are drawn with Tuscan Red. Flesh is added to the bottom lip for color. I applied a little black to the inside corners of the mouth to create depth and dimension.

With your Tuscan Red, begin to place tone on the outside edges of the face.

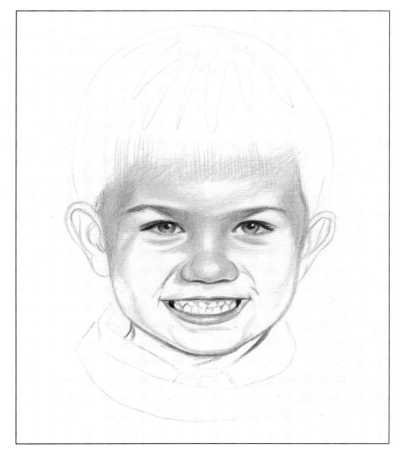

Render the shadows and the contours of the face with Tuscan Red. Be sure to work from dark to light, just as we did with the sphere exercises. Add a little Flesh color to the gum area on the bottom teeth.

With Dark Brown, add some tone and definition under the chin and jaw.

Continue to build the skin tones by adding colors. Terra Cotta should be applied next as a transitioning color out of the Tuscan Red—as it would be if going from dark to light on a color value scale. Flesh would be added next to soften all of the colors into the color of the paper.

A small amount of Olive Green has been added into the shadow areas on the left side of the face, neck and temple areas.

When drawing a facial portrait, it is not necessary to draw a lot of the clothing. I usually draw the neckline and shoulders and fade it out into a *V* shape. The sweater has been simplified and drawn in lightly with Tuscan Red and Scarlet Red Verithins. Light Gray was used for the shadows in the shirt collar. Black and Tuscan Red are found in the shadow next to the neck.

Color As a Finishing Touch

All three of these were drawn the same way, using the same colors, drawn on the same color of mat board (no. 1008, Ivory). These are my children, depicted at approximately the same age.

By having them all matted with the same color combination, they then become a matched set that can be used for a wall grouping or memory wall.

Look and see how the peach and pale blue colors of the mats pick up the colors of the drawings and seem to enhance them. This is an important factor when framing your work. You should always select colors found in the artwork, using the mat colors as a visual tool.

Colors used:	Dark Brown, Tuscan Red, Carmine Red, Terra Cotta, Golden Brown and Flesh (skin tones). (Note: Carmine Red gives the baby skin a rosy look.)
Clothing on Shelly:	True Blue, Gray and Dark Brown Verithins (shadow areas) white Prismacolor
Clothing on LeAnne:	Flesh and Tuscan Red (shadows) True Blue and gray (lace) white Prismacolor
Blankets, LeAnne and Christopher:	True Blue and Dark Brown
Hair:	Dark Brown, Tuscan Red and Flesh
Eyes:	black, Indigo and white burnished Prismacolor. Even though all of my kids have blue eyes, each one of them has a different shade of blue.

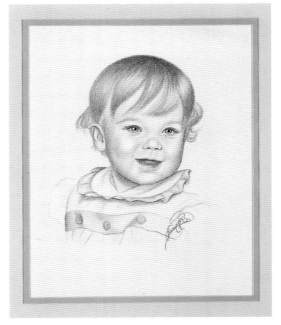

"Shelly Ann"
10" × 13"
(25cm × 33cm)

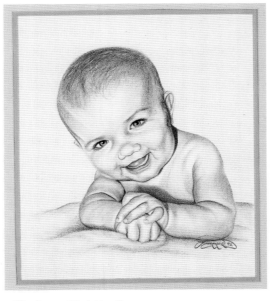

"Christopher Dale"
10" × 13"
(25cm × 33cm)

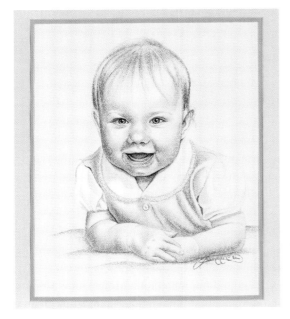

◄ "LeAnne Christine"
10" × 13" (25cm × 33cm)

Background Color

By adding a background color with shading to your drawing, you can change the entire look. Both of these drawings have a halo of purple behind the subject matter. When using color like this, it is important for you to use the color correctly by bounding the background into the subject itself. Everything reflects color from the things around it. People reflect color from their surroundings and the clothes they are wearing. By placing the purple in the background, I also had to place the purple into the skin tones to make it look realistic. Look carefully at the skin tones. They are drawn with the same skin tone formula that I always use, but I added the purple Verithin into it. If I had used red in the background instead, I would have had to put red into the drawing. The same would be true for any color used in the background. Experiment and see how different colors will affect the skin tones.

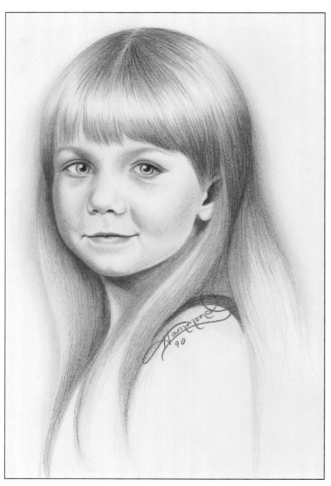

"LeAnne"
Verithin on no. 1008, Ivory mat board.
11" × 14" (28cm × 36cm)

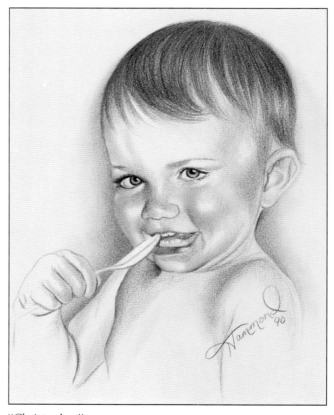

"Christopher"
Verithin on Ivory Canson Mi-Teintes paper.
9" × 12" (23cm × 30cm)

The Texture of Mat Board

Layering with Verithin pencils can create very soft drawings, as clearly seen with this example. This particular drawing was done on a mat board that had a texture to it. Can you see the difference this texture makes? It changes the way the colors look, especially in the darker colors of the background and the shirt. Compare the look of this drawing to the previous examples. I have used the same colors in this one as I did for the three baby pictures, yet this one takes on an entirely different look.

The application of the dark background shading (Indigo and True Blue) helps make the light skin tones show up better and makes the blue of the shirt appear softer and less competitive with the face. The texture of the mat board gives the shirt a woven look.

Colors used: Dark Brown, Tuscan Red, Terra Cotta, Flesh (skin tones)
True Blue, Indigo (clothing and background)
Dark Brown, Golden Brown, Tuscan Red, Flesh (hair)
Black-and-white Prismacolors were used for the eyes.

"Shelly"
Layered Verithin on no. 3297, Arctic White mat board.
16" × 20"
(41cm × 51cm)
A small amount of Indigo Blue was layered into the hair, along the jawline and the side of the face.

A Complex Drawing

The layering technique need not be reserved just for simple, soft subject matter. A very complex, detailed drawing can be done with these pencils, even with a limited amount of colors. The following example shows you just how involved a drawing can be.

Up until now, I have kept the illustrations fairly simple in order for you to fully understand the techniques. To learn, you have to start with simple studies and then advance. For this reason, I have deliberately excluded complex pictures with backgrounds and fore-grounds. This allowed us to concentrate on the subject matter more fully. But now, I will show you how to fill the page using not only your subject, but other elements as well to help you tell a story with your artwork. This is what true illustration is all about.

All artwork has a main subject. But illustration tells a story and has other things in it for the viewer to see. Look at this example. The old Cambodian woman is the main subject matter. This is what the artwork wants you to look at first. The baskets and the surroundings are the secondary subject matter, which then tells you something about the main subject matter. All of these elements combine to tell a story about the character. It could also be called a character study since it is more than a portrait, or just what someone "looks" like. Character studies tell you something about the subjects, how they live or how they feel. This is my favorite type of artwork and is why I always have a camera around my neck or in my purse.

"An Old Cambodian Woman"
Photograph taken by Marsha Clark
Layered Verithin on no. 912, India mat board.
16" × 20" (41cm × 51cm)

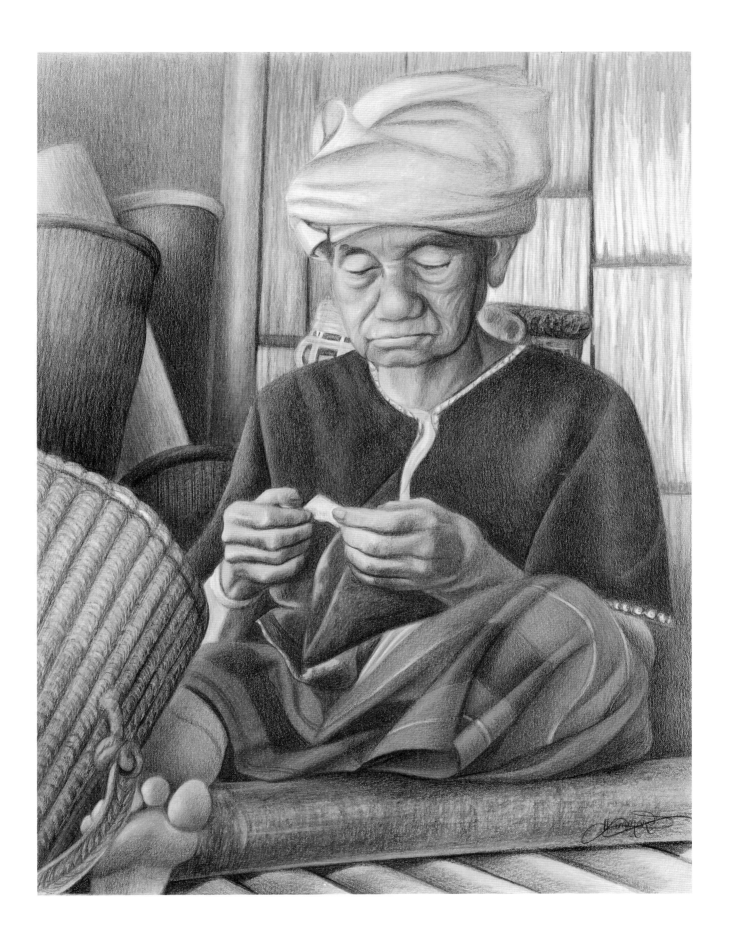

Close Attention to Details

Now that we have established the theme of this artwork, let's discuss the technique and how it was done. It was layered just like the more simple drawings shown previously, but it had more area to cover and took more time to complete.

Although this appears to be very complex, it was actually drawn with a very simple combination of colors. Look for the colors Dark Brown, Tuscan Red, Terra Cotta, Carmine Red, Vermilion, Flesh, Golden Brown, Indigo Blue, black and white as you study this piece. Black and white Prismacolors were used to deepen the shadow areas and create the bright highlights. Other than those two colors, the entire drawing was done with Verithin pencils. By enlarging and isolating various areas of the drawing, you can see more clearly how this was drawn.

◄ DETAIL OF THE FACE AND HAT

Because this drawing was done on a gold-colored paper, the gold comes through in the color of the face. Notice how the Indigo Blue of her shirt is reflecting into the shadow area of her face, on the right side, and on the bridge of her nose. Also, the red of her skirt is bouncing up onto the lower lip and chin. Because she is sitting in sunlight, I used white Prismacolor to highlight the bright areas of her face.

The hat too is showing the gold color of the paper underneath. The shadow areas were done using Dark Brown and Indigo Blue combined, with white Prismacolor for the bright highlight areas.

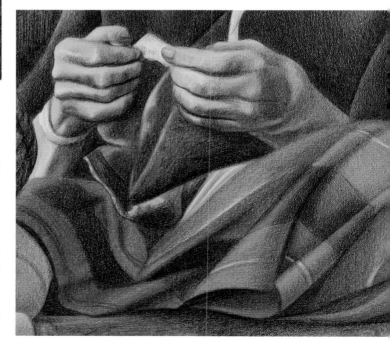

DETAIL OF THE CLOTHING AND HAND ►

If the clothing of this drawing had been done in Prismacolor, the colors would have burnished together, making the fabric take on a smooth, silken look. Verithin, on the other hand, never builds up enough to burnish. This allows you to layer colors on top of each other. The result is a textured look, giving the appearance of a weave in the fabric.

The hand is reflecting the colors of the fabric from above and below. Can you see the red on the lower portion of the hand? At that area, the hand and the fabric are the same colors and are merely separated by the shape and highlights. The blue spots on her hands are tattoos and are put in last with Indigo Blue.

DETAIL OF BASKET AND FOOT

Look for the sphere exercise when you look at this foot, especially in the toes. The colors of the skin were applied slowly, allowing the color of the paper to enhance the skin tones. The darker colors (Indigo and Dark Brown) were layered in on top of the lighter colors.

The basket is a wonderful example of texture. The pencil lines have been put in to replicate the weave of the basket. Look for the pencil strokes and you should be able to see their direction, as well as how they create the roundness of the weave. The shadow area is reflecting the Indigo Blue from the surroundings. White Prismacolor was used to create highlights on the outer surfaces where the sunlight hits it.

DETAIL OF UPPER LEFT CORNER

These baskets and wood are not nearly as textured as the baskets below. Still, the direction of the pencil strokes creates what texture there is. It was important while drawing this area to pay attention to where the light was affecting each surface. Since they all are rounded, it was important to include the five elements of shading to create form. Again, look at how the color of the paper is coming through and giving it a warm glow.

DETAIL OF UPPER RIGHT CORNER

This wood was created with vertical pencil strokes. The highlights were put in with white Prismacolor. This lightness makes the woman stand out and gives you a good feel for where the light is coming from.

BURNISHING WITH PRISMACOLOR

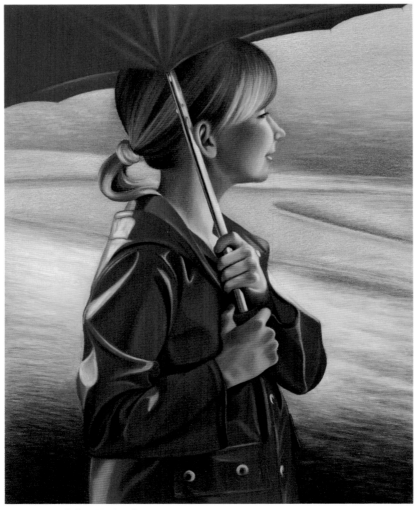

Colors used: *The entire skin tone palette.*
White, cream, Light Peach, Deco
Peach, Blush Pink, Deco Orange,
Salmon Pink, peach, Goldenrod, pink,
Carmine, Scarlet Lake, Crimson,
Magenta, Henna, Mahogany Red,
Tuscan Red
Scarlet Red, Poppy Red, Carmine Red,
Tuscan Red, black and white (umbrella
and raincoat)
Golden Brown, Sienna Brown, Tuscan
Red, Yellow Ochre, black and white.
All of the reds from the umbrella and
the raincoat are reflected into the hair.
(hair colors)
Dark Green, Apple Green, Indigo Blue,
Chartreuse, Spring Green and Grass
Green (grass areas)
Cool Gray 90 percent, black, white and
reflected red (umbrella handle)

"Annie and the Umbrella"
Prismacolor on no. 3322, Blue Porcelain mat board.
16" × 20" (41cm × 51cm)

Using Prismacolors

With Prismacolor, you can create artwork that rivals the look of an oil painting. Because of its deep rich colors and the ease of blending, the possibilities are endless for you. Combined with the Verithin pencils, you have everything you need to create outstanding artwork.

We have covered many techniques so far and have seen the possibilities and limitations of each. The technique presented in this chapter will be the most challenging one.

I use many more colors with this technique than I do with the others. Burnishing allows you to layer many colors on top of each other, thus creating new colors. The look is smooth, gradual and vibrant. "Annie and the Umbrella" (the preceding illustration) is a good example of that.

Skin Tones

Look at the skin tones on this drawing. Because of the lighting and the way the reds of the coat and umbrella are reflecting, I used every skin tone available. I was able to create a convincing depiction of how the colors were being bounced off the different surfaces.

To create unusual skin tones like this, you should start with the usual basic hues. The red tones are then gently layered and blended on top. The exercises in this chapter will take you through the process of burnishing, showing you how to blend colors on the face.

Complementary Colors

One of the things that makes this particular piece so striking is the use of opposite colors. Whenever two colors that are opposite each other on the color wheel (or complementary colors) are used together, they make each other stand out. By placing the bright red outfit against the brilliant green background, you have a color combination that really makes you pay attention.

Burnishing

Burnishing takes a lot more time than the layering technique, so be patient. All of the colors you use must be applied quite heavily in order to cover the paper surface completely. Then, every color added must be blended in. This is done by using a lighter color over the existing colors to soften them in gently. It is a back-and-forth, repetitive process that can become tedious, but it also allows you to keep changing your work again and again until it takes on the look you want. At any rate, the time invested is worth it when you see the outcome.

Many times you will mix the various techniques. Not often will an entire drawing be done solely in one technique. This chapter will show you many examples where part of the drawing will be burnished, with the rest of it completed with layering.

Step-By-Step

Begin just as you did with the layering exercise, since the procedure is similar in the first stages. Although we will be completely covering the paper surface, I still selected a peach-colored paper, shell renewal. This warm color will add life to the completed drawing, even though the color will not come through in the skin tones like it did with the layering. Instead, I will create similar colors with the Prismacolors.

Reference photo.

Using a graph, I drew a light outline of the face and all of the features with a mechanical pencil. I was sure to get the circles of the eyes accurate by using a template. It is very important not to move on from this stage until you are positive of all of the shapes and their accuracy.

Always start with the eyes. Black Prismacolor is used for the pupil and white Prismacolor is used for the white of the eye and the catch light. For the iris, I used Indigo Blue. I outlined it with black and burnished white over it to make it look shiny. For the membrane in the corner of the eye, I used Tuscan Red and Flesh and carried those colors up into the eyelid.

To begin the shadow areas around the eyes and up into the eyebrow area, I used a Tuscan Red Verithin.

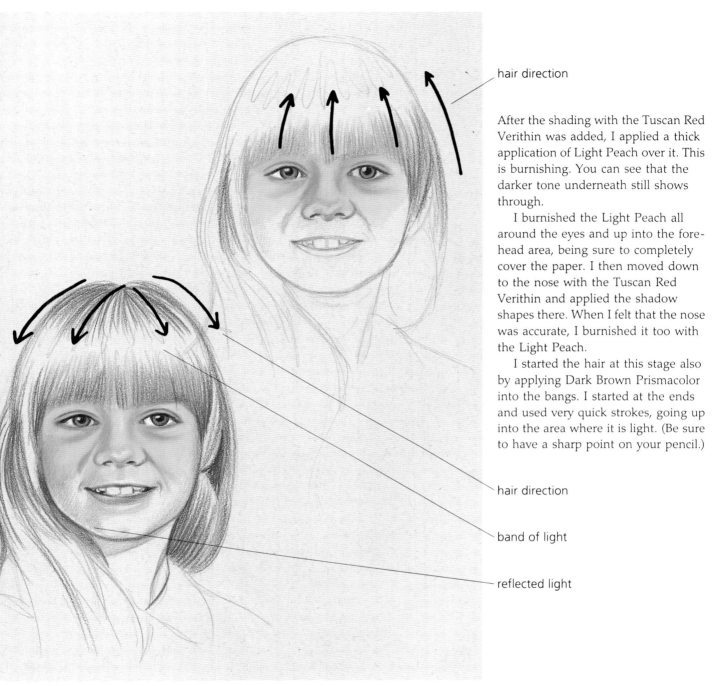

hair direction

hair direction

band of light

reflected light

After the shading with the Tuscan Red Verithin was added, I applied a thick application of Light Peach over it. This is burnishing. You can see that the darker tone underneath still shows through.

I burnished the Light Peach all around the eyes and up into the fore-head area, being sure to completely cover the paper. I then moved down to the nose with the Tuscan Red Verithin and applied the shadow shapes there. When I felt that the nose was accurate, I burnished it too with the Light Peach.

I started the hair at this stage also by applying Dark Brown Prismacolor into the bangs. I started at the ends and used very quick strokes, going up into the area where it is light. (Be sure to have a sharp point on your pencil.)

The mouth is next. Watch the shape of those teeth! Start the lips with Tuscan Red Verithin. I applied Dark Brown Prismacolor into the corners of the mouth and into the little shapes under the teeth.

I then began the light shading around the outside edges of the face with the Tuscan Red Verithin. Notice the reflected light around the jawline that was left uncovered. Also, I blocked in the shadow on the neck.

To shadow under her eyes, I added a small amount of Flesh. I added more of the Flesh color to the eyelids, to the forehead where the hair had been placed and to the lips for shine. I continued to work on the hair, adding more Dark Brown into the dark areas. Using the same quick stroke, I went from the top of the head downward, to the lighter area. I was sure to follow the direction of the hair itself. I then went back to the bangs and going up, used quick strokes to darken them.

Step-By-Step, Continued

To complete the drawing, I finished the burnishing with the Light Peach Prismacolor. I completely covered the entire face and the neck area. To add more color into the face, I added more Tuscan Red and Flesh to the shadow areas. These tones were lightened too much when burnished the first time, so I reapplied some color for definition.

To finish the hair, I added Burnt Ochre, Terra Cotta and Goldenrod to create the blonde colors. I then burnished those colors in with a white Prismacolor. Whenever I added a color, I always drew it in, going with the direction of the hair.

It is a balancing act of adding dark tones, medium tones and light tones until you create the coloration you want. But the most important part is the highlights. They should always be applied on top of the other colors and be made to look like they are on the outer surface of the hair.

If you compare my drawing with the photo, you will see that I smoothed out the hair to make it look more styled and attractive. You as the artist always have the option of improving on nature.

I drew in the collar of the dress with a white Prismacolor, adding some shadow to it using the Burnt Ochre seen in her hair. I simplified the dress so it would not compete with the face. I used a Scarlet Lake Prismacolor to fill in the color and softened it toward the bottom with a scarlet Verithin. For the shadow under the color and on the shoulder, I used the Dark Brown Prismacolor and added some highlights on the shoulder with white.

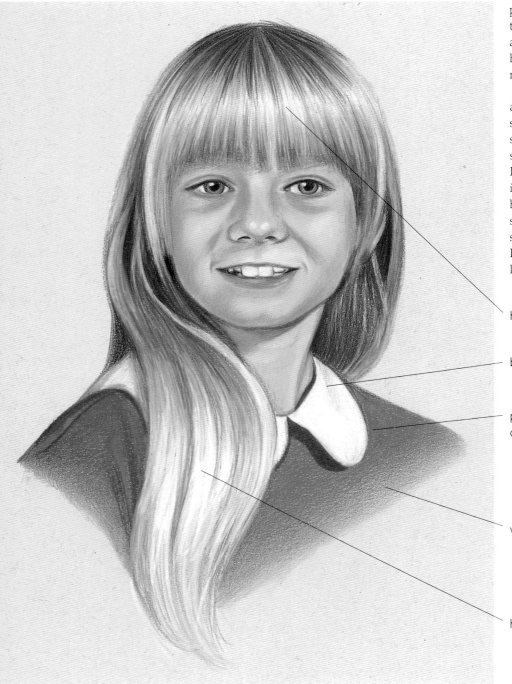

highlights

burnt ochre

prismacolor for color

verithin to soften

highlights

Soft Colors

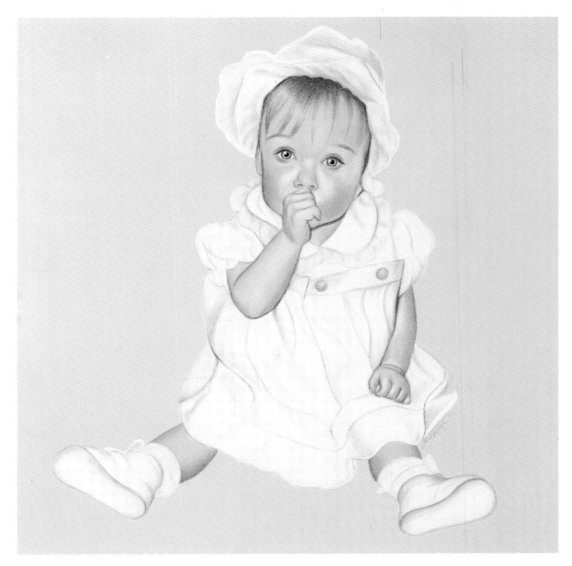

"Innocence"
Prismacolor and
Verithin on no.
901, Apricot mat
board.
16″ × 20″
(41cm × 51cm)

The skin tones on this drawing were layered with Verithin pencils on no. 901, apricot mat board. The color of this drawing surface creates beautiful skin tones for you. I used Tuscan Red for the edges and shadows, and Scarlet Red for the rosy little cheeks. White Prismacolor was used to highlight the cheeks alongside the nose.

Another reason I selected this mat board was the use of opposite colors again. I wanted somehow to make the baby's outfit stand out.

Since the outfit is a turquoise color, the peach color was perfect because orange and blue are opposites. The two colors really work together well, giving it a soft but direct look.

The dress is burnished using Aquamarine, Light Aqua and white. The darker Aqua was applied first in the direction of the folds and creases, and then the white was burnished over it. I was then able to blend in more Aqua on top wherever I needed it, always softening it in with the white.

For the bonnet and the shoes, I used white and added a little Cold Light Gray for the shadow areas. I applied this lightly. Can you see how the color of the paper is still showing through in certain spots?

Since this drawing turned out so cute, I didn't want to clutter it with a background. That's the beauty of artwork. Keep it simple or make it complex. You have the choice as the artist to do whatever you want to do.

Strong Colors

This is also a combination of both Prismacolor and Verithin, but it is the burnished, bright colors of the Prismacolor that gives it its intensity and appeal. As we saw in the "Annie and the Umbrella" piece, reflected, bouncing color is an important element of this drawing too. Look and see how the yellow color of the carnival lights are reflected down into the skin tones and the hair. It can also be seen down the left side of the shirt. The reds, yellows and oranges are seen clearly in the face, giving it a very warm glow.

The shirt is an example of pure burnished color. I made sure in my preliminary pencil line drawing that the stripes of the shirt were accurate, following the stresses and curves of the fabric. I then filled in the stripes according to the photo I was working from. The colors used were: Aquamarine, Scarlet Red and white. I used Ultramarine Blue for the shadow areas in the blue stripes to make them darker. White highlights were then added over the top of the completed stripes to show the ripples in the shirt. Canary Yellow was added to highlight the left side. The merry-go-round pole was created with Canary Yellow, gold, Yellow Ochre and white. The hair was made with Dark Brown, Tuscan Red, Canary Yellow, Carmine Red and white.

By using an indistinct layered background, the background does not compete with the main subject matter, allowing your full attention to be placed on the little boy. (This was my son's first solo ride on the merry-go-round. As he went around and around, he could not find me in the crowd, which is why he has the "I'm-not-sure-I-like-this" look on his face.)

"Criffy and the Merry-Go-Round"
Prismacolor and Verithin on no. 1008, Ivory mat board.
16" × 20" (41cm × 51cm)

Lighting

Lighting can be one of the most important elements of artwork. Here are some examples of how lighting created the mood and interest in the subject matter.

To have light, you must have darks. By placing a dark shadow along the side of the face in the portrait on the left, the light side of the face is better displayed. It also helps balance the ones in the drawing by offsetting the dark area along the back of her head. This is important to do with the colors and tones in your artwork. Lights and darks should be evenly distributed for balance. (We will cover more of this in chapter 13, Composition.)

I had my camera out and ready to go when I saw the pose on the right being created. It was the light more than the subject matter that caught my eye. Look at how the light is dancing off her back and the sleeve of her shirt. Without that, the drawing would not have nearly the artistic quality that it has.

Opposite colors were used for this drawing too. Because of the green tones, I chose to draw on a mat board with more of a pink cast to it, since red and green are opposites. The pink helped with the skin tones and made the greens seem more vivid and true. This drawing would not have looked as good if I had drawn it on a blue or yellowish background. Be sure you consider all factors that will help enhance your work and lead to a pleasing result.

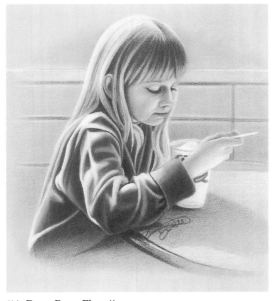

"A Root Beer Float"
*Prismacolor and Verithin on no. 3315,
Porcelain mat board.*
9" × 11" (23cm × 28cm)

Colors used: Prismacolor: Grass Green, Peacock Green, Dark Green, black (sweater)
Dark Brown, Yellow Ochre, Terra Cotta, white (hair)
Verithin: Tuscan Red, Flesh, Yellow Ochre, Carmine Red, white (skin tones)
Dark Brown, Indigo Blue, Yellow Ochre (bricks and shadow areas)

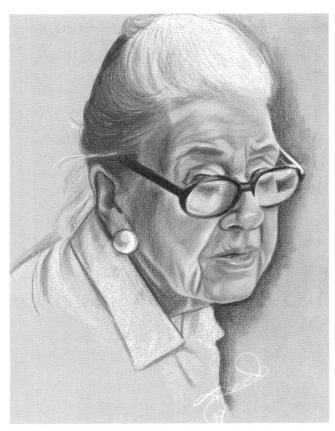

"Aunt Lil"
Prismacolor on Green Canson Mi-Teintes paper.
8" × 10" (20cm × 25cm)

A Slick Surface

This is another good example of filling the page and telling a story with your artwork. But this time, I used the Prismacolors on an entirely different surface than I normally use. This was done on what is called drafting vellum—a thin, transparent film. I attempted this as an experiment for my students and was pleasantly surprised with the results.

I found that the colors seemed to become almost translucent on the film's surface, giving the artwork a somewhat surreal quality. The textures and colors have been heightened by the vellum's surface, making it look photo-realistic. But this is very difficult paper to work on. Because of its slick surface, it does not layer well. It actually seems to repel anything after the first one or two layers of colors are applied. This makes it a little hard to handle and pretty unforgiving. Although I did find myself getting frustrated, I was pleased with the final product. I cannot recommend this to anyone except the very seasoned colored pencil artist. If you are very confident with the colored pencils, then perhaps you will like the challenge as I did.

This piece is another example of what to look for when taking photos for drawing references. The patterns of the bricks, wood, wallpaper and chair fabric all lead the eye to the bright colors in the center of the composition. This makes for a compositionally sound drawing.

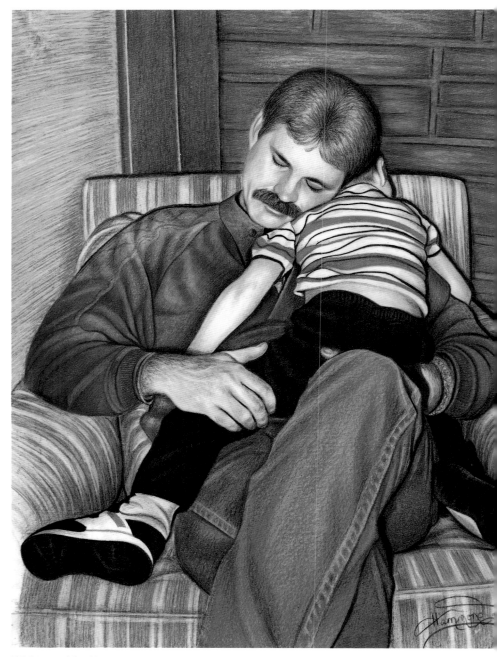

"Taking a Nap"
Prismacolor on drafting vellum.
14" × 17" (36cm × 43cm)

Texture

While using a textured board is often a good way to create the look of texture in your drawing, sometimes the texture you are wanting to create must be done with your pencils. This piece is the "ultimate texture exercise."

The fur of the hat and coat was drawn by layering small pencil strokes on top of burnished Prismacolor. This is the same quick stroke used for drawing eyelashes and eyebrows, just a whole lot more of it!

First, the entire area was filled in and burnished with Prismacolor, in shades of blue, grey and white. That created the basic form and roundness by establishing the light source and the shadow areas. I used Cool Grey 90 percent, Warm Grey 30 percent, French Grey 50 percent, Indigo Blue, Peacock Blue, Cloud Blue, black and white. Very quick strokes were applied, beginning with the dark areas first. Again, use a very sharp point on your pencil!

The layers were built up slowly until it started to look furry. If you look closely, you can see where the light strokes are overlapping into the dark areas, and the dark strokes can be seen in the light areas. Because of the extreme light on the right side, it appears to fade into solid white, with very few pencil strokes showing.

To help with the texture even further, I "scratched" into the fur with the point of a craft knife. This technique must be done with great care so that you do not accidentally gouge the surface of the paper. By doing this, you can soften the pencil strokes into one another and gently add some lighter hairs into it, creating a much more layered effect.

A gentle layering of Verithin blues along the side of the face helps define the face and also ties in and repeats the blue in other parts of the drawing. See how the blue is then found in the shadow areas of the face?

"Winter White"
Prismacolor on no. 916, Autumn Mist mat board. 16" × 20" (41cm × 51cm)

Telling a Story

A student of mine came to class one evening and showed me a photograph of her father and her granddaughter. She asked if she could learn to draw it someday. Naturally I said yes, but I also told her that I would be drawing it first! I absolutely fell in love with that picture, and to this day, this drawing is my favorite piece of artwork and probably always will be. How fortunate I am that she was kind and generous enough to share it with me. (Thanks, Jo!)

Because of the clear, large photograph, I was able to see and create many colors that normally wouldn't be seen in a picture. You can see the heightened level of realism that was captured because of this. The better the photo, the better the artwork—it's as simple as that!

For this piece, I used a combination of layered Verithin and burnished Prismacolor. By looking at the drawing in sections, you will be able to see why I did it this way.

"Hollis Dahlor and His Great Granddaughter, Mackenzie"
Prismacolor and Verithin on no. 916, Autumn Mist mat board.
Photograph by Jo Louis
16" × 20" (41cm × 51cm)

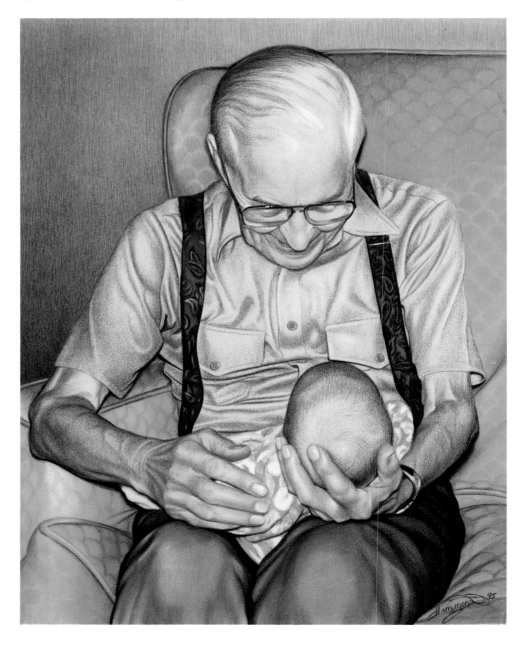

A Closer Look

THE FACE AND HAIR

The face has many colors in it because it is reflecting all of the colors from the surroundings. Along with the usual skin tones, I used greens and blues in the details. The angle of the face made it difficult to see the features. For this reason, I had to be very careful to draw exactly what I saw in the photograph, and not what I *thought* should be there. Notice how you cannot see the eyes because of the eyeglasses, and you can't see the mouth due to the nose. Yet, if drawn just the way they appear in the photo, it all looks complete.

The face was layered with Verithins. This gives the skin and hair a more realistic texture. Look at how smooth and silky the hair looks against the texture of the skin.

The hair is a combination of layering and burnishing, thin lines and thick lines, Verithin and Prismacolor. It is a multitude of colors, including blues, greens, grays, pinks, black and white. Look closely and you can see how the skin is showing through.

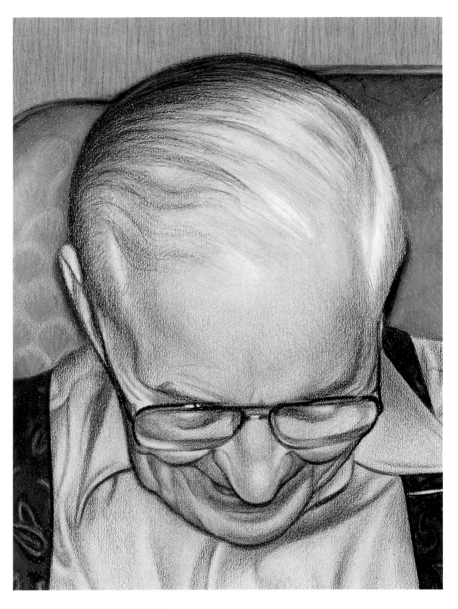

THE SHIRT AND SUSPENDERS

The shirt was also layered with Verithins, using a lot of colors for effect. The shadow areas are darkened with Dark Brown, Sienna Brown, Tuscan Red and Indigo Blue. Great care was taken to accurately depict the wrinkles, curves and creases of the fabric. A small amount of white was added to the areas that stick out the most and gather the most light.

The suspenders were burnished to stand out against the texture of the shirt. The paisley print was achieved with Tuscan and Carmine Red, along with Indigo and True Blue. The dark shadow areas were placed in with black.

THE CHAIR

The jacquard print of the old chair was heavily burnished with Prismacolor. Since this type of fabric is shiny and reflective, the lighting affects the way the patterns of the material stand out. The patterns on the upper portion of the chair appear to be dark against light, while the patterns further down, behind his shoulder, appear to be light against dark. Under his elbow on the left side, the light is particularly strong, and white was used to create that. Where he is sitting, the pulls and creases of the fabric have been drawn with Indigo Blue.

THE BABY'S HEAD AND THE HANDS

The baby's head gets more comments from people than any piece of artwork I've ever done. It basically was drawn just like the sphere exercise, going from dark to light, using the typical skin colors. A little Olive Green and Indigo Blue were added also.

The swirls of hair were added with Dark Brown and gray Verithin. The strokes followed the natural swirl of the hairs.

The hands were created with the same skin tones using a little more Terra Cotta and Carmine Red for the redness. Finger shape is very important; they must be seen as angular and geometric, rather than round and rubbery.

CHAPTER TWELVE

DRAWING ON COLOR

Throughout the book, I have discussed how much the paper color you choose impacts the finished look of your artwork. A drawing done on warm peach tones, for instance, will have a completely different look than one drawn on ice blue. Great thought must go into this aspect before you even begin your drawing. Whenever possible, choose a color that will directly enhance and help create the colors of your subject matter.

"Uncle Frank at Cannon Beach" is an excellent example of that theory. Look at the photograph I used for reference. Although the sky was a bright blue, it was not what I wanted to stand out in my drawing.

The beautiful color of his skin and the sunlight on his clothing are what I found so artistically appealing. By choosing the Brick Red mat board, I had just the right color to enhance both.

Drawing on a paper with darker tones will help the highlights in your artwork naturally stand out more. This can give your work a lot of impact and visual appeal because of the extreme contrasts.

Look at how the highlights are standing out in this drawing. By placing just a halo of blue behind the subject, the full attention then goes to the face and clothing. You seem to get a real feel for the warmth of the sunshne by the way it lights up the face, arm and surfaces of the fabric. To show it off even more, I picked up the blue tones in the colors of the mats I framed it with.

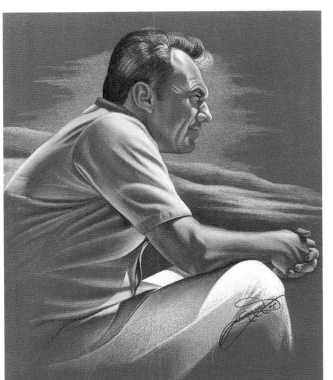

"Uncle Frank at Cannon Beach"
Prismacolor on no. 1041, Brick Red mat board.
16" × 20"
(41cm × 51cm)

This snapshot shows how different the artwork and the photo reference are. Be creative, and try not to simply reproduce a photograph.

Skin Tones, Light and Dark

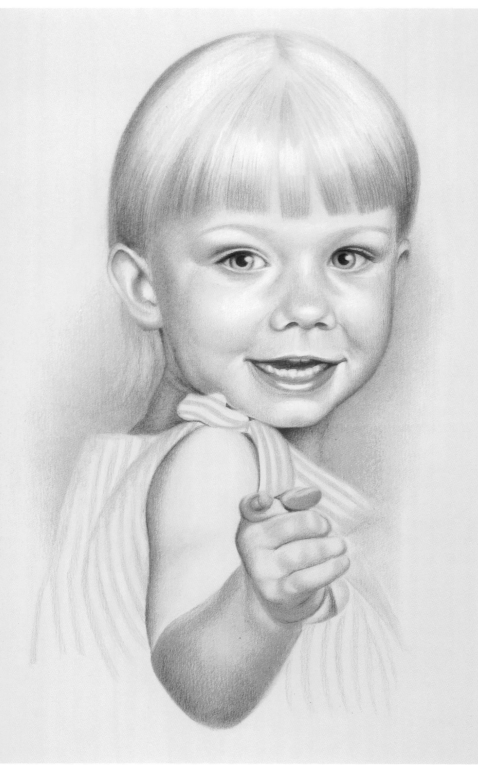

"My Baby"
Col-erase blended on no. 1030, Pastel Pink mat board.
12" × 16" (30cm × 41cm)

Skin tones should always be your first consideration when choosing a paper to draw on since they are usually the most important colors in your drawing. In these examples, we have entirely different skin colors, with two colors of mat board helping to create them.

The drawing, "My Baby," is drawn on no. 1030, Pastel Pink. By drawing this with the Col-erase pencils, I was able to blend the skin colors with a tortillion into the pink of the paper. The result is cute baby skin. Opposite colors (green against pink) were used once again to make it stand out. I used a little blue in the shading also, to help pick up the colors of the eyes.

The rich bronze color of Martin Luther King Jr.'s skin is nicely created with no. 1058, coral paper. Because of its similarity to the real skin tone, very few pencil colors were required to do this drawing. Black, Dark Brown and Indigo Blue were the colors I used for the shadow areas. Where the skin was more true to color, like a halftone (midtone, not a highlight and not in shadow), I used Dark Brown and Terra Cotta. The Terra Cotta was a good transition color, since it is so close to the color of the paper and gently softens the other colors into it. It creates a very smooth blend of tone.

Take note of the hair. Since all hair is drawn going in the direction of the hair's growth, this style was created with very small, circular strokes. To keep it soft looking, I used the side of my pencil lead.

Practice this and you'll see just how easy it is.

To make this drawing stand out, I used some color behind it. Since the paper and the subject were so close to the same color, I needed to use something to break it up. The use of opposite colors came to the rescue again. By placing a small amount of Indigo Blue (the opposite of the coral color) around the face, it made the face stand out more.

The second drawing was also done on the coral-colored mat board. Although her skin tones are not as dark as the other drawing, the color still proved to be a beautiful foundation to draw on. As you can see, the blue tones play an important role in this piece, by standing out against the coral color.

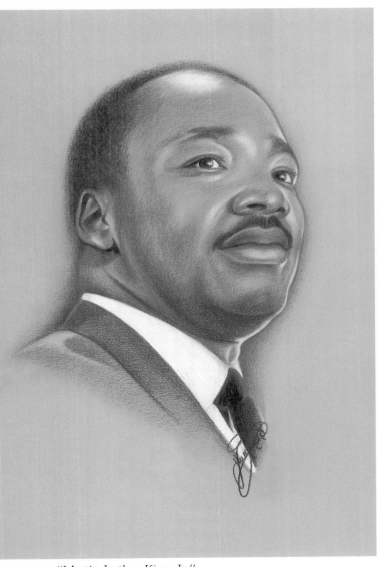

"Martin Luther King, Jr."
Prismacolor on no. 1058, Coral mat board.
11" × 14" (28cm × 36cm)

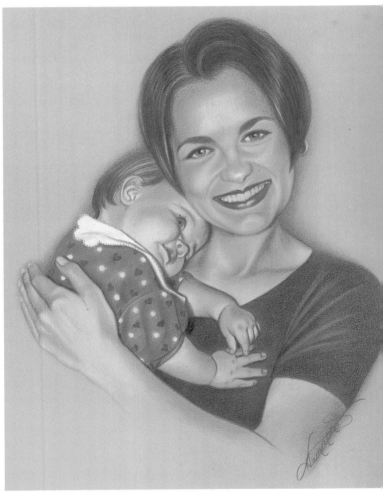

"Kirsten and Claire"
Prismacolor on no. 1058, Coral mat board.
10" × 13" (25cm × 33cm)

Drawing on Black

Drawing on black paper can be an exciting break from the usual skin or earth tones. The intensity created by the extreme contrasts can make your drawing appear very striking.

A simple drawing of white against black, like the one below, can look far from ordinary. Like any interesting drawing, it's the light that gives it appeal. This pose has the lighting coming from the back of the subject and shows how an extreme lighting situation actually conceals part of the model's face. It reduces the face to mere shapes, but is still very descriptive. You don't always have to draw a subject in its entirety for it to look good. This type of lighting works particularly well when drawing on black paper.

Sometimes just the addition of a single color or two can be used for impact. The bottom right drawing uses a combination of black, with two opposite colors (orange and blue). Combined with the expression on this face, I have created a very eerie feeling with this drawing.

To help enhance the tones of the drawing on the opposite page, I used the white and black oval mat for contrast. The white of the mat helps the very light areas of the drawing stand out. The sunglasses are a good example of this.

Working on black or dark paper gives you a keen appreciation of the eye-catching power of contrasts, and is an effective way to create dramatic results.

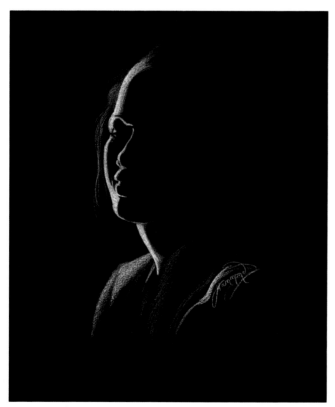

Example of extreme contrasts.
White Prismacolor on black.
9" × 12" (23cm × 30cm)

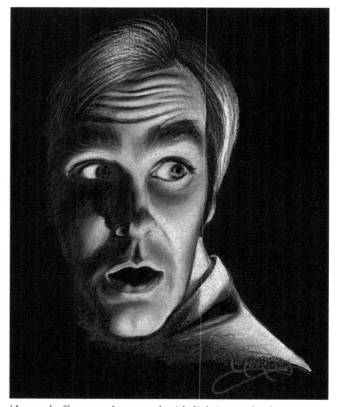

Unusual effects can be created with lighting and color.

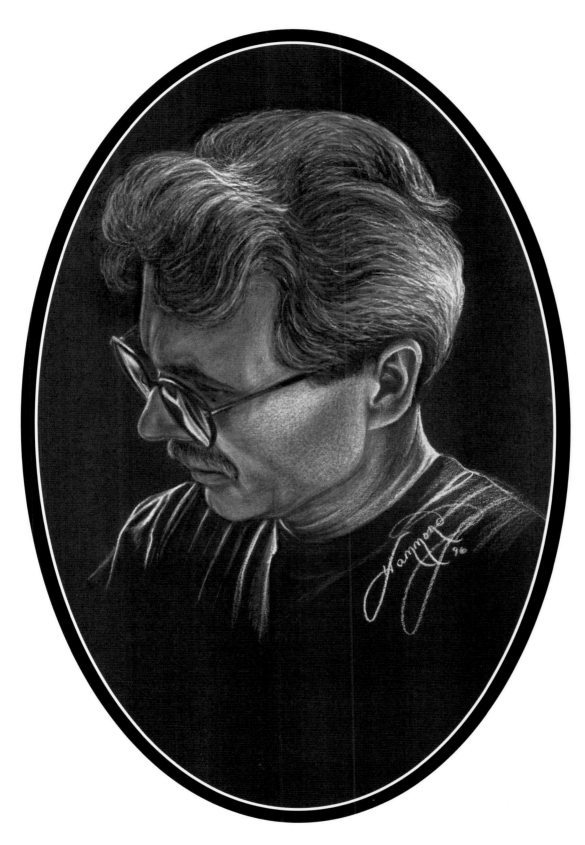

"Gus"
White Prismacolor and white Verithin on black. Verithin was used on the face for smoothness.
9" × 12" (23cm × 30cm)

Lighting

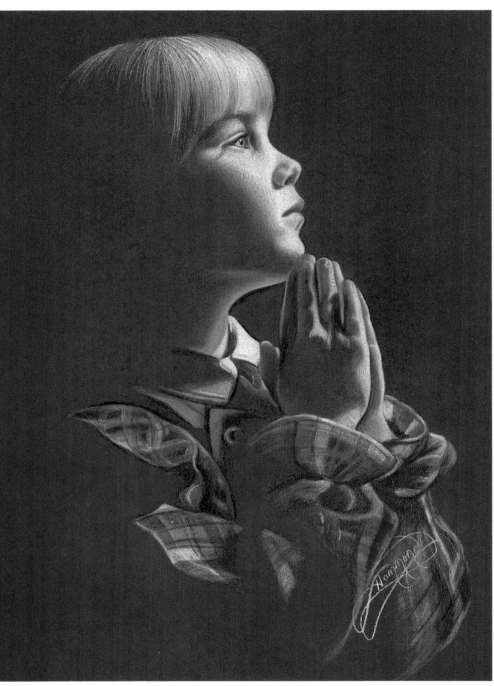

"Now I Lay Me Down To Sleep"
*Burnished Prismacolor on Coal Black
Artagain paper.*
12" × 18" (30cm × 46cm)

Lighting is everything, especially in a high contrast drawing like this. The surfaces of the face, hands and clothing are defined not only by the extreme lighting, but also by the intense shadows created.

Lighting has a strong effect on color, and in this piece the color is being bounced and reflected onto many of the surfaces. Look at how the red from the clothing is bounced up onto the neck, jaw and hands. This same red color is seen along the shadow edge of the face.

Special attention was given to the plaid clothing. While I did not try to replicate every single detail seen in the photo, I did try to give a convincing illustration of plaid. I followed the direction of the fabric and the way the pattern changed as it went in and out of the folds and creases. By taking these things into consideration, I think I was able to create a believable plaid.

When working with thick colors to cover the black paper, you want to be sure to spray it good when you are done. This will keep the colors from clouding up with wax bloom as we have discussed before. I used several layers of spray Gloss Damar Varnish for this piece. It helped intensify the colors and make the drawing more vivid.

COMPOSITION

Knowing how to draw something is very important, but how do you properly place it on the page? A well-rendered drawing will not look professional if poorly positioned on the paper. Every piece of art should have good compositional balance. Balance is created by placing the subject matter on the page in such a way that its artistic weight is evenly distributed.

Balancing the Layout

The shapes of your drawing must be arranged so that the drawing does not seem heavy on one side or another, or from top to bottom. Your subject matter should always be closer to the top than the bottom. This keeps the area above the subject from weighing it down. Empty space must be balanced with subject matter, and large subjects should be offset with smaller ones.

Balancing Color

Color must also be balanced. The lights and darks should be evenly distributed and colors repeated around the entire drawing. It is important that all of the dark colors do not end up on one side with the light ones on the other.

If you have blue in the upper portion of your drawing, then blue should be found elsewhere, in the center and somewhere near the bottom. I try to repeat all of my colors in a triangular fashion, making sure that each color is seen in at least three areas.

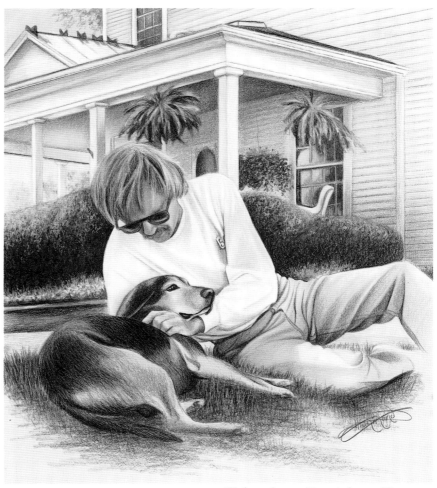

"Bob, at James Dean's house"*
Prismacolor on no. 916, Autumn Mist mat board.
16" × 20" (41cm × 51cm)
*Some of you may remember my brother-in-law "Bob" from my first book. Unfortunately, Bob passed away unexpectedly as I was writing this book. This is my tribute to him. I'll miss you!
Robert F. Hammond (1950-1996)

Basic Layouts

There are four basic compositional layouts to follow when arranging your subject matter. All of them are designed to lead the viewer's eyes around the picture plane and to the main focal point of the drawing. Never do you want the eye led off the page. Your subject, tones and color should always be arranged in one of these four formats:

 1 round or oval
 2 square or rectangular
 3 triangular
 4 diamond

The illustrations that follow will give you some ideas and examples of how these different formats are

The basic compositional shapes.

used effectively with a variety of techniques.

This is an example of a rectangular composition created by the reclining positions of the subjects. The stripes of the couch help lead the eye to the center of the drawing. The edges of the drawing are gently faded out so that the focal point remains in the center of the

drawing, without the eye being lead outside of the picture plane. This piece is also balanced with its tones. The darkness of the hat is offset by the darkness of the clothing. The flesh tones are repeated in a triangular fashion around the picture. All of these elements combine to make this a perfectly balanced composition.

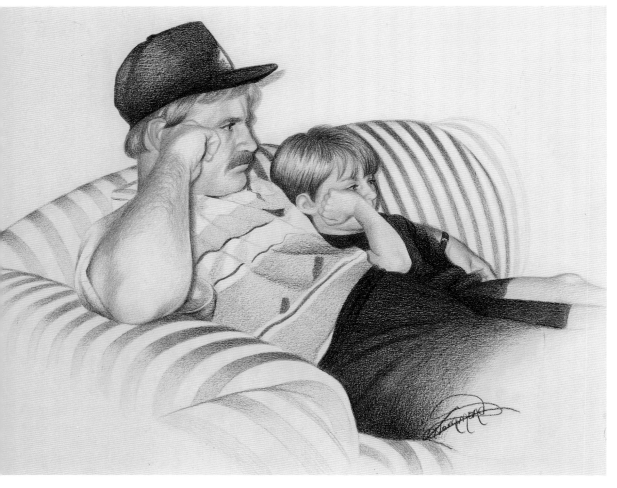

"Like Father, Like Son"
Layered Verithin on no. 1014, Olde Gray mat board.
12" × 16"
(30cm × 41cm)

Using Color for Balance

As seen in the previous drawing, the furniture in your picture can act as a compositional tool. Whether the pattern of the fabric acts like a road map to lead the eye around the picture or as a weight to balance the subject matter, use it to your own advantage. Here are a couple more examples to show you how.

This first portrait has a rectangular composition. I love the way she is posed in the picture, but to draw it I really need to include the chair to balance her on the page.

I used color for balance also, repeating the colors around the piece. For instance, the red of the chair can also be found in the red of her lips and in her skin tones. The brown of the chair's wood can be found in the color of her hair. The green of the outfit is also in the color of her eyes and in the background shading. I used the opposites red against green for impact.

The second piece also uses the furniture to help offset the weight of the subject matter. Although I have drawn this piece in a rectangular format, the subject within the drawing creates a triangular composition by the way he is sitting.

I used color for compositional balance, too. I chose to use the same color as his jeans for the background. This keeps all of the dark tones from making the picture bottom heavy. The brown wood color is repeated above in the skin colors, and all of the colors in the drawing can be seen reflecting in the fabric of the couch.

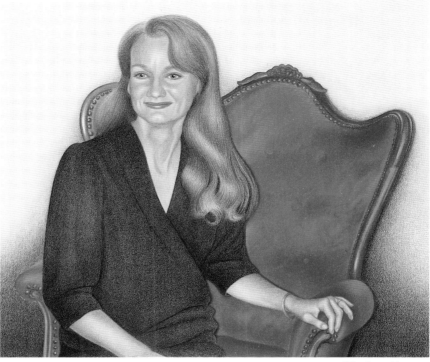

▲ ''Barbara''
Prismacolor and Verithin on no. 1008, Ivory mat board.
16" × 20"
(41cm × 51cm)

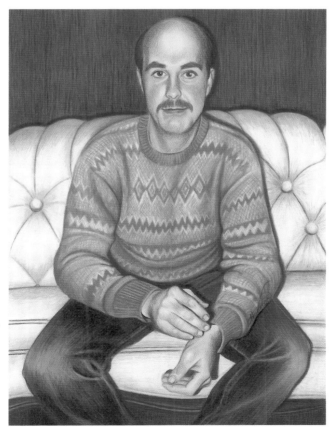

''Dan''
Prismacolor and Verithin on no. 1009, Jonquil mat board.
10" × 14"
(25cm × 36cm)

Cropping

An interesting composition can also be created by cropping—cutting off the drawing with an abrupt edge. Usually part of the subject is cut short and contained by the border or edge.

In both of these examples, I deliberately contained the subject matter within a rectangular format. But I was careful to balance them compositionally within that format. Both of these pieces are triangular compositions by the way the subjects are placed on the page. (It is wider at the bottom because of the shoulders and smaller at the top of the head.) Shading in the upper corner of each helps offset the weight of the subject with the use of color playing an important part.

To keep the skin tones soft in the first piece, I allowed the color of the paper, no. 3332, Tea Rose, to come through, and used a light application of Verithin for the tones. The rest of the drawing was done with burnished Prismacolor. Notice how I used the stripes of the shirt as a way of leading the eye into the center of the drawing. Look for these types of things in your photos, which will help you lay out your composition.

The second drawing, because of its intense colors, was completely burnished with Prismacolor. I selected a neutral color of mat board no. 3305, English Stone to draw on, which was close to the color of the hair—the area most likely to reveal the paper color.

The bright colors of this drawing help attract attention. Look how the colors are repeated. The front of the shirt is the same color as the lips. The white of the sleeves and collar can also be seen in the highlights on the top of the head, the earrings and the teeth. The colors of the background are reflected into the white areas of the shirt and the highlights of the hair.

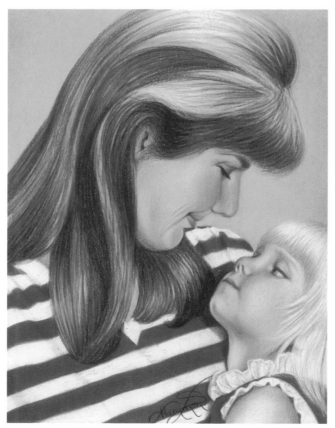

"Me and My Baby"
Verithin and Prismacolor on no. 3332, Tea Rose mat board.
6" × 8" (15cm × 20cm)

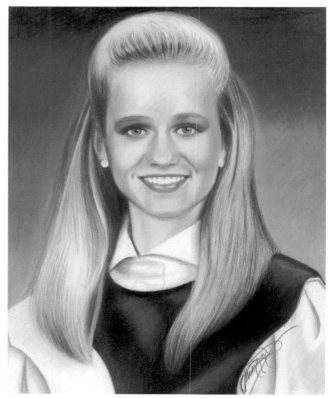

"Kim"
Prismacolor on no. 3305, English Stone mat board.
8" × 10" (20cm × 25cm)

Borders

Another way of cropping your artwork is by creating an outline or border around it. This can be done by drawing it in with a straight edge or by using what is called border tape. Border tape is purchased on rolls, is self-adhesive and comes in many different colors and widths. To apply it to your work, simply draw a light line where you want the tape to go and then press the tape along the guideline. Cut your edges with a craft knife, mitering the corners like a picture frame by cutting on the diagonal.

When I use border tape, I like to make my subjects stand out with it. I will allow the subject to come out of the border in places, giving the illusion that the tape is going behind them. Look at how the portrait of the old man stands out by doing this.

Although the border tape creates a rectangular format around the subject, the subject itself is creating an oval composition because of the shape of the head. Notice that the mat I selected not only repeats the shape of the border, but also repeats the gray tones of the drawing, which ties everything together.

In the drawing of Chris, not only did I use border tape, I used shading to darken the corners and create a natural framework. Once again, the border creates a rectangular format, but this time the pose within is in a triangular composition.

The rectangular and triangular compositions are the most common ones found in artwork, especially when drawing single subjects. Because of the width of the shoulders, most portraits will be shaped like a triangle. A person sitting down will then balance the figure into a rectangular shape.

When placing two or more subjects on one page, the arrangement will usually fall into an oval, round or diamond shape layout.

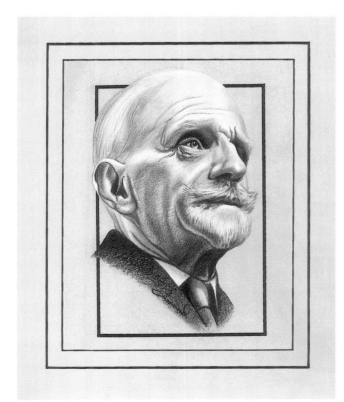

"A Distinguished Gentleman"
Black-and-white Prismacolor with border tape on Gray Canson Mi-Teintes paper. 11" × 13" (28cm × 33cm)

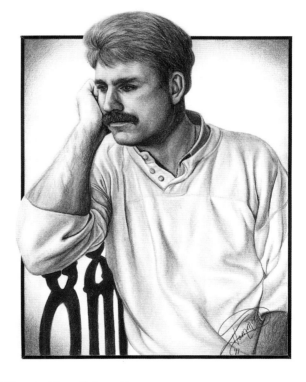

"Chris in New Orleans"
Black Verithin and Prismacolor with border tape on white illustration board. 16" × 20" (41cm × 51cm)

Matting

The matting you choose for your artwork can also play an important part in creating the composition. Just as cropping and borders add interest, the mats surrounding the work almost become part of the artwork. Look at how important the mats are in these two examples. Great care was taken when selecting these.

Both of these mats are cut into an oval shape. I chose these for my artwork because of the shape of the subject matter. If you look closely, you will see an oval shape being created by the poses in the drawings. The oval mats repeat that shape, making everything work together.

Color was another important consideration. It is always necessary to repeat the colors of your artwork into the colors of the mat. In "Criffy and Daddy," the blues were highlighted, giving the entire piece a soft pastel appearance.

The pink teddy bear cut into the mat for the drawing of Annie helps create a cute toddler look for the artwork. These specialty mats can be purchased at most frame and craft stores.

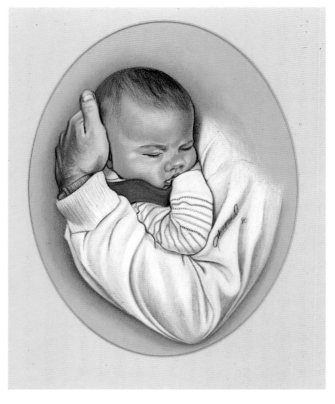

"Criffy and Daddy"
Prismacolor on no. 909, English Rose mat board. Matted with no. 972, French Blue 16" × 20" (41cm × 51cm)

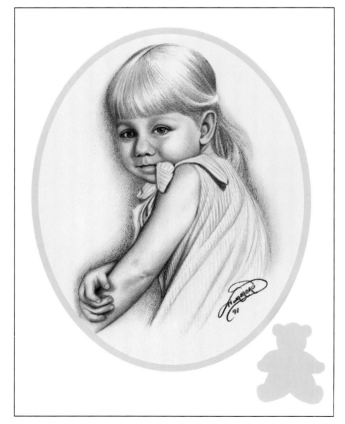

"Annie"
Prismacolor and Verithin on no. 1008, Ivory mat board. 10" × 13" (25cm × 33cm)

MIXED MEDIA WITH COLORED PENCIL

Just as you have learned to use different types of colored pencils together to create different looks, you can also mix them with other mediums. Many interesting effects can be created by using a mixed media approach.

One of my favorite combinations is pen and ink with colored pencil. With "stippling" (also known as pointillism), I create the shape and tones of my subject using nothing but thousands of dots and very few lines. By itself, this is a beautiful technique which gives the artwork a clean, graphic look. But by adding a light tint of color, the whole look changes to something unique and special.

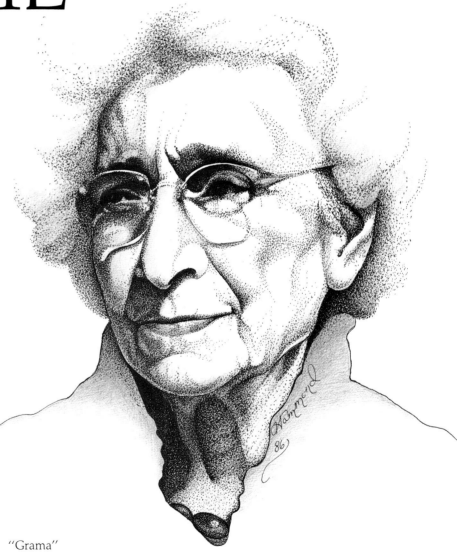

"Grama"
Stippled pen and ink with layered Verithin (Flesh, Lavender, Carmine) on 2-ply bristol (smooth).
11" × 14" (28cm × 36cm)

Stippling

All of these drawings were stippled with pen and ink. A very light application of Verithin was then added to the completed drawings. Since all of the shading and tones are created with the pen and ink, a single color can be added for a multicolor look. The tones underneath the color make the color seem to change. This makes it an easy technique to try since the tones do not have to be created with color.

For all of these drawings, the skin tones were created with a very light application of Flesh Verithin. Since this type of paper is very, very smooth, your pencil should be extremely sharp, with the strokes of the pencil being extremely close together so it fills in evenly.

For the drawing of Dad, I used border tape to create a rectangular composition. The background was done with the stippling, but I layered a tint of Dark Green over it to help the flesh color stand out on the face.

It is not always necessary to use realistic color. As you can see by this pen-and-ink study and the one of my grandmother on page 117, unusual color can look great! Experiment with different color combinations and do not be afraid of how it will look. The nice thing about pen and ink is that you can make photocopies and experiment as much as you want to see how various colors will look on your work.

You are not limited to just pen

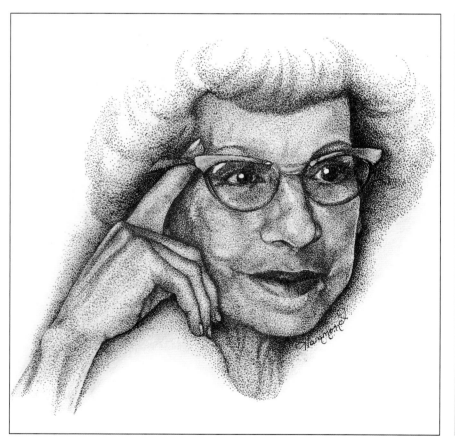

"Aunt Lou"
Pen and ink (stippled).
Layered with Verithin (Flesh, Indigo Blue, and Carmine Red).
2-ply bristol (smooth).
11" × 14" (28cm × 36cm)

"Dad"
Pen and ink with border tape.
Layered with Verithin (Flesh and Dark Green).
2-ply bristol (smooth).
11" × 14" (28cm × 36cm)

and ink. This example also has some graphite blended into it for more intense shading. I completed the drawing with pen and ink first, and then added the graphite on top. I used tortillions to blend it out.

When I had the graphite finished, I sprayed the drawing with workable fixative. I was then able to add the Verithin colors on top of it without them mixing together and becoming muddy.

"Grampa"
Pen and ink.
Layered with Verithin (Flesh and Dark Green).
2-ply bristol (smooth).
11" × 14" (28cm × 36cm)

"Deep Thought"
Pen and ink.
Layered with Indigo Blue Verithin.
2-ply bristol (smooth).
11" × 14" (28cm × 36cm)

"Sharing Time"
Pen and ink and graphite.
Layered with Verithin (Green, Indigo
Blue, Dark Brown, Tuscan Red and gray.
White Prismacolor was used to highlight
the hair.)
White illustration board.
16" × 20" (41cm × 51cm)

Tinting

For an artistic style that resembles the old-fashioned tinted photographs, you can layer your Verithins over graphite drawings. For anyone who has learned the blended pencil technique, this is a fun and exciting way to dress up those drawings with color. It gives them an entirely different look!

Notice how delicate the color appears when placed over the graphite. It is the smoothness of the graphite underneath (which has been blended with a tortillion) that almost gives it a porcelain look. Be sure to use a smooth two-ply bristol to achieve this look. Mat board has too much texture and will not give you this smooth appearance.

Remember, you must always spray the finished graphite drawing with workable fixative before you apply the color. If you don't, the grayness of the graphite will smear into the colored pencil and dull the colors. Be sure to allow ample time for the spray to dry completely before you continue drawing.

Untitled portrait
Graphite layered with Verithin (Flesh, Carmine, Sea Green).
2-ply bristol (smooth).
9" × 12" (23cm × 30cm)

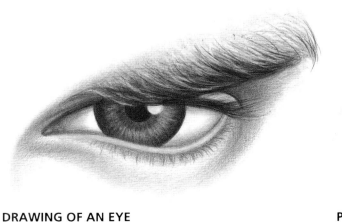

DRAWING OF AN EYE
Graphite layered with Verithin (Flesh, Carmine and Indigo Blue). A few strokes of Dark Brown were used in the eyebrow and eyelashes. 2-ply bristol (smooth).

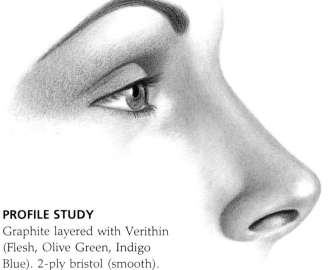

PROFILE STUDY
Graphite layered with Verithin (Flesh, Olive Green, Indigo Blue). 2-ply bristol (smooth).

Fashion Illustration

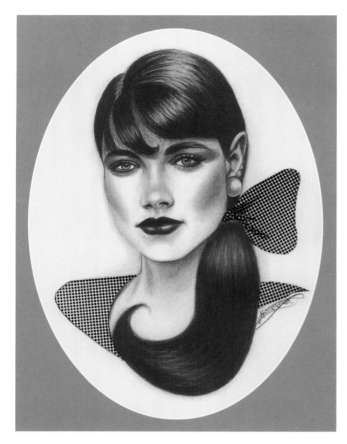

◀ Fashion illustration is also a fun thing to draw using the mixed media approach. The face and hair of this drawing were rendered first in graphite and the blending smoothed with a tortillion. The drawing was then sprayed and tinted with color, using the Verithins. What is different about this piece is the use of graphic film. The dot pattern on the shirt and hair bow was applied with a self-adhesive sheet that resembles contact paper. It can be cut to any shape you need using a craft knife. It comes in a large variety of patterns and colors and gives a truly unique quality to your work.

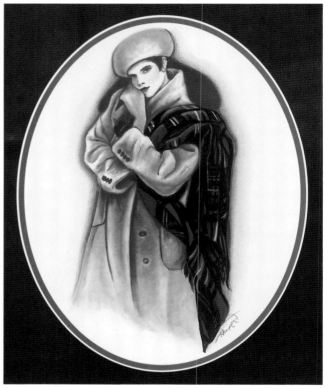

This fashion illustration was done with a combination of graphite, colored pencil and acrylic paint. The coat, hat and face were all done in the graphite and a tortillion. Because I wanted the plaid scarf to really stand out against the gray tones, I painted it with the acrylic and a paintbrush. This made the colors even brighter than they would have been had I drawn them with colored pencil. I then put a halo of red around the drawing with Scarlet Lake Prismacolor. I also tinted the lips and cheeks with some Carmine Red Verithin.

◀ Another fashion illustration using colored pencil over graphite. The mats on this drawing also repeat the colors found in the drawing.
Colors used: Tuscan Red, Crimson Red and True Blue Prismacolor.

Watercolors

Have you ever tried drawing with colored pencil on top of watercolor? For those of you who enjoy the spontaneity of watercolor but like the colors and details of colored pencil, this may be something you will want to try.

"Sand Castles"
Watercolor detailed with colored pencil. Illustration board. 16″ × 20″ (41cm × 51cm)

Colored pencil was used to help define the details of the background trees and the hair blowing in the wind. Also, some details in the shirt were added along with some of the texture in the sand. This piece was sprayed with damar varnish to intensify the colors.

"Indian Chief"
Transparent watercolor detailed with colored pencil.
Arches 90 lb watercolor paper.
11″ × 14″ (28cm × 36cm)

This has all of the qualities of a watercolor painting with the loose, fluid look that we all know. But a closer look will reveal that some of the color and small detail lines in the face and around the eyes have been added with colored pencil. This was painted with brown and black watercolor only. Tuscan Red, and Olive Green Verithin was added into the face and headdress. White Prismacolor was added into the lines of the face.

"Best Friends"
Prismacolor and Art Stix on textured
Oatmeal paper.
11" × 14" (28cm × 36cm)

CONCLUSION

This drawing was done on a very rough surface. It is a paper called oatmeal. I chose it for a very good reason. The other drawings in the book consisted mostly of faces, and a textured paper would not be suitable for capturing the smoothness of skin. This drawing, however, is different.

The small figures in this piece are surrounded by very textured surfaces. The pebble-like finish of the oatmeal paper actually helped create the gravelly look of the road and the foliage of the trees and bushes.

To lay in the large areas of color, I used Art Stix. These are square sticks of color made with the same pigments used in the Prismacolor pencils. When drawing large, loose areas such as this landscape, they can help you apply large areas of color quickly. They do not require sharpening and can be used on their edge or on the side.

When I was finished, I sprayed this drawing with damar varnish to brighten the colors and prevent the waxy buildup from clouding the colors.

Colored pencil is truly one of the most versatile mediums available. Whether used alone or combined with other mediums, the look is always special. I am so pleased to see colored pencil artwork finally getting the recognition and appreciation that it has so long deserved.

I hope that by reading this book you have been inspired to try colored pencil, maybe in some ways you have never thought of before. Experiment with it, and given time, I'm sure that you will love it as much as I do!

Regardless of what your own personal drawing style is or the type of look you prefer, colored pencil can give you the results you are looking for. The possibilities are endless, and you will find your own unique way of expressing yourself with this medium.

I believe that each and every one of us has been given a gift. All of the magnificent colors present in this world are at our fingertips, just waiting for us to take notice. We, as artists, have been given a second gift! We can feel and explore all of those colors through our artwork. See it, and you can draw it. Draw it, and you have captured the moment forever!

Let colored pencil help you showcase the colors in your life. Best of luck always in your creative adventure!

Sincerely,

INDEX

More Great Books for Beautiful Art!